WATKINS GLEN
RACING

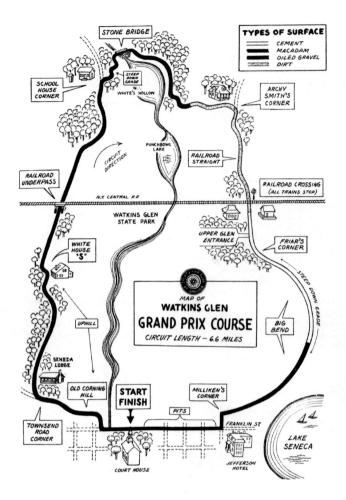

New Yorker cartoonist Sam Cobean's affectionate (and often reproduced) view of the original racecourse has become an integral part of the heritage of Watkins Glen racing. Cobean, who lived locally and drove his own sports car, was an enthusiastic supporter of the early races. He was killed on a summer's drive not far from his home. Passenger Cameron Argetsinger, who was ejected from Cobean's car, survived.

On the front cover: John Bennett, seated in his super charged MG TC, waits for the start of the 1952 Watkins Glen Grand Prix. (Courtesy of the International Motor Racing Research Center.)

Cover background: The Seneca Cup race is pictured here. (Courtesy of the International Motor Racing Research Center.)

On the back cover: These cars are starting up Old Corning Hill in the 1951 Queen Catharine Cup race at Watkins Glen. (Courtesy of the International Motor Racing Research Center.)

WATKINS GLEN RACING

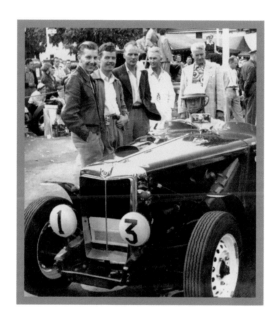

Kirk W. House and Charles R. Mitchell

ARCADIA
PUBLISHING

Published by Arcadia Publishing
Charleston, South Carolina

Printed in the United States of America

Library of Congress Catalog Card Number: 2007942668

For all general information contact Arcadia Publishing at:
Telephone 843-853-2070
Fax 843-853-0044
E-mail sales@arcadiapublishing.com
For customer service and orders:
Toll-Free 1-888-313-2665

Visit us on the Internet at www.arcadiapublishing.com

To Cameron Argetsinger, whose vision of racing at Watkins Glen

still delights the world 60 years later.

C O N T E N T S

ACKNOWLEDGMENTS

Much of the history of racing at Watkins Glen might have been lost, or at least overlooked and dissipated, except for the creation of the International Motor Racing Research Center at Watkins Glen (www.racingarchives.org). Everyone interested in racing heritage owes the center a vote of thanks, and we owe it special thanks for generously opening the archives to us. The bulk of the images in this book came from the center, where executive director Mark Steigerwald and historian Bill Green steered us through the archives. Besides the center and the track itself, visitors in Watkins Glen can stroll the downtown, scanning sidewalks for inset plaques commemorating those Watkins Glen racing stars who have been honored by induction into the Watkins Glen Walk of Fame. Brochures are also available to guide a drive along that wonderful, original 6.6-mile route through the countryside—make sure you do not miss the chance.

Artist Bob Gillespie, whose work may be found, among other places, as exterior murals in Watkins Glen, very graciously allowed us to use several of his images here. Our small black-and-white reproductions do not do justice to his vividly colorful limited-edition prints. Check them out at www.glenspeed.com.

Charles and Melissa Mitchell took contemporary photographs. Ade Ketchum of Motorace Graphiks (adekfoto@stny.rr.com) allowed us to use two of his images. Michele Benjamin at the Schuyler County Chamber of Commerce (www.schuylerny.com) and Leon Bourdage from the Art of Ferrari (www.artofferrari.org) arranged permission for us to use several images, and Teresa Angelo at In-House Graphic Design helped us with collection and transmission. Many thanks to all—this book would not exist without them.

INTRODUCTION

World War II was over and fairly won. Experts had given up on Pres. Harry S. Truman's election hopes against Thomas E. Dewey, Strom Thurmond, and Henry Wallace. The first baby boomers were learning to walk and talk. Prosperity was bursting unrestrained, and the Depression was receding into the memory of a nightmare. Americans were back on the road again, and Cameron Argetsinger had an excellent idea.

Why not do something that had not been done since well before the war? Why not gather sports car drivers from across the country for a race? Not a race on a closed course but a race like a European grand prix . . . over hills, down dales, and along well-traveled streets. Why not revive American road racing?

Argetsinger had the dream, and he had the venue. As a summer visitor and as a student at Cornell University in Ithaca, he often motored over the hills to Watkins Glen at the head of Seneca Lake. This was a village of medium size but well accustomed to crowds of visitors. They swarmed into Watkins each year to enjoy the largest of the Finger Lakes or the state park starring the spectacular glens and gorges for which the town was named.

A month before Dewey defeated Truman (you can check the November 3, 1948, *Chicago Daily Tribune*, if you do not believe it), Argetsinger and others made the dream come true. The Watkins Glen Chamber of Commerce and the Sports Car Club of America (SCCA) joined forces to stage a new event. Argetsinger laid out a challenging 6.6-mile course. The village, towns, state, state park, and county closed their roads, while the New York Central Railroad stopped the train. The curator of the Smithsonian Institute came to announce the grand prix and junior prix, each of which Frank Griswold won in his Alfa Romeo. Ten thousand spectators cheered. Sports in America (and in the world) had a new tradition—racing at Watkins Glen.

The races were exciting and dramatic, and the setting was exquisite. But the course was demanding, and tragedy struck twice, killing a driver in 1950 and a seven-year-old spectator in 1952. The following year a new sponsoring body, the Watkins Glen Grand Prix Corporation, moved racing to a new 4.6-mile course on nearby rural roads. After three years of that, a closed course arose on the new site, designed in part by engineers from Cornell University.

At 2.3 miles in length, the closed course was shorter than either of its predecessors. But designers reproduced in miniature the contours of the 1948 to 1952 route, neatly uniting the new track with its heritage.

International and professional events began booking in, beginning with the NASCAR Grand National in 1957. Watkins Glen activities soon included the U.S. Grand Prix, which had long been a dream of Argetsinger. In 1965, drivers named Watkins Glen the best-organized grand prix in the world. Watkins also hosted NASCAR races, Indy cars, the Can-Am, Sportscar Vintage racing, and more. In 1973, five years after Woodstock, the track even hosted a summer

rock concert featuring such groups as the Allman Brothers and the Grateful Dead. That day is still vividly recalled by 650,000 attendees and shell-shocked local residents.

In 1971, the track was completely redesigned and re-created, extending the length to 3.377 miles and upgrading visitor facilities. The greatest names in racing competed as Watkins Glen played host to Mario Andretti, Richard Petty, Graham Hill, Giles Villeneuve, Geoff Bodine (a local boy who watched the races from a tree as a kid), Jeff Gordon, A. J. Foyt, Davy Jones, Dale Earnhardt Sr. and Dale Earnhardt Jr., Jackie Stewart, Bobby Unser, and Al Unser Jr. Paul Newman won the Sports Car Club of America National in 1985, finishing second that same day in the Trans-Am. Tom Cruise raced in the national two years later. National Football League star Walter Payton set a track record in 1989 at the Sports Car Club of America Pro Sports 2000.

Even so, things faltered with time, and the debt load from that 1971 rebuild remained high. The track went into receivership in 1982 to be rescued by a white knight whose identity might have puzzled anyone living outside the immediate area. Nearby Corning was home to Corning Incorporated, a Fortune 500 company formerly known as the Corning Glass Works. Corning, in keeping with its long-standing policy of building up its home community, bought the track and reopened it in 1984 as Watkins Glen International. Derek Bell won its first race, the six-hour Camel Continental, in a Porsche 962.

Things improved, and by 1997, Corning's operating partner the International Speedway Corporation had purchased the again-vibrant course at Watkins Glen. For its 60th anniversary year in 2008, Watkins Glen International scheduled major events, including Sahlen's Six Hours of the Glen, Watkins Glen Historics racing, SCCA Glen Nationals, NASCAR Sprint Cup Series, Zippo 200 NASCAR Busch Series, Corning 100 Indy Pro Series, the U.S. Vintage Grand Prix, and more—not to mention the huge Finger Lakes Wine Festival and other events. Designers and manufacturers also hire the course privately to test their newest innovations under wraps.

In some ways, 60 years seems like a long time, and in other ways, it seems like the blink of an eye. Certainly the world has changed profoundly since that October day in 1948, when Truman was fighting for his political life, Richard M. Nixon and John F. Kennedy were freshman congressmen, and nobody went into space but Buck Rogers and Flash Gordon. Racing at Watkins Glen has changed, too. But some of those who were there that very first day are still among us now. And the hills of the Finger Lakes still echo to the rumble of the engines, and the spectators' hearts still stir.

THROUGH THE STREETS

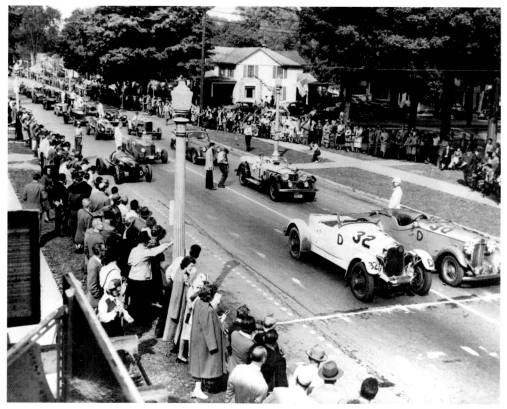

History is almost in the making here. The crowd is casual but eagerly engaged. The vehicles—nearly all prewar models—are lined up in their starting grids on Franklin Street. The weather, of course, is perfect. The drivers, including macabre *New Yorker* cartoonist Charles Addams, are prowling, awaiting the start of the 1948 junior prix, the first official race at Watkins Glen.

DIVISION OF
OPERATION AND MAINTENANCE

REFERENCE:
PERMIT NO. ___6-344___

V. L. OSTRANDER
SUPERINTENDANT

STATE OF NEW YORK
DEPARTMENT OF PUBLIC WORKS

Chas. H. Sells
Superintendant of Public Works

ALBANY 1

APPLICATION FOR PERMIT

TO: CHAS. H. SELLS
 Superintendant of Public Works of the State of New York.

Application is hereby made by the Village of Watkins Glen,
N. Y., through its Mayor, A. D. Erway, to permit the use of
portions of the Watkins Village-Franklin Street, S. H. 5335, and
the Townsend-Watkins S. H. 5557, and all of the Watkins Glen
State Park Entrance S. H. 1917, situate in the Towns of Dix and
Reading, County of Schuyler, as shown on the map hereto attached,
for the purpose of conducting over the said highways the First
Annual Grand Prix Automobile Races on October 2, 1948. In the
event of unfavorable weather conditions on October 2, 1948, the
races will be postponed to October 3, 1948. The races are to be
conducted in accordance with the conditions and regulations here-
inafter set forth, and forming a part hereof. The applicant will
obtain any other consents or permits that may be necessary to
accomplish the purposes set forth herein.

A. D. Erway, Mayor, Village of
Watkins Glen, N. Y.

Dated Sept. 1, 1948 Approval recommended Sept. 2, 1948

BY:
 H. F. Brumm, District Engr., Dist. 6

PERMIT
PERMISSION IS HEREBY GRANTED

Here is an item for the history books: it is a carbon copy of the original permit from New York State held in the Cameron Argetsinger files. Notice the momentous line at the bottom: "Permission is hereby granted."

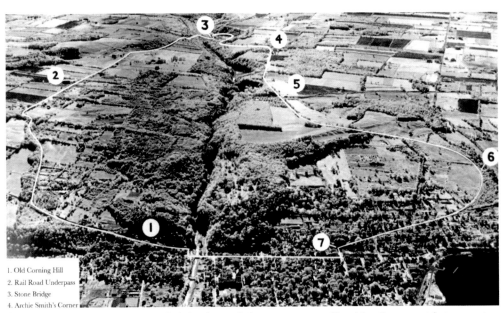

1. Old Corning Hill
2. Rail Road Underpass
3. Stone Bridge
4. Archie Smith's Corner

This aerial photograph gives a feel for the 10-kilometer course. Franklin Street, with its starting and finishing line, is the long, straight stretch between point seven and point one. The Esses lie just after point three. The head of Seneca Lake is at the right. Just to the right of point one (and to the left of point three) is the gorge of Watkins Glen, preserved forever by a New York State Park. Compare this image with the Sam Cobean map on page 2.

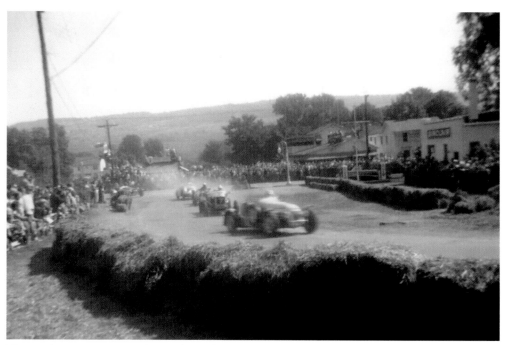

Notice the spectators on the roof at right. This image shows the cars starting up Old Corning Hill after taking the first turn of the course.

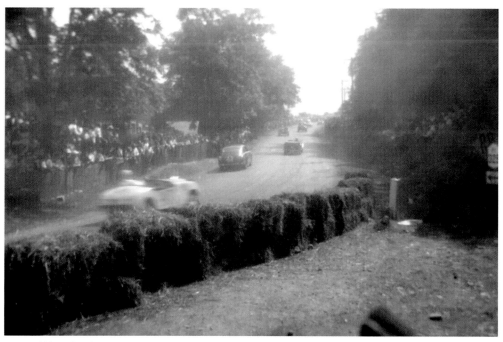

It is still hard to beat a venue like this for racing. This scene is just a short way up the hill from the image above.

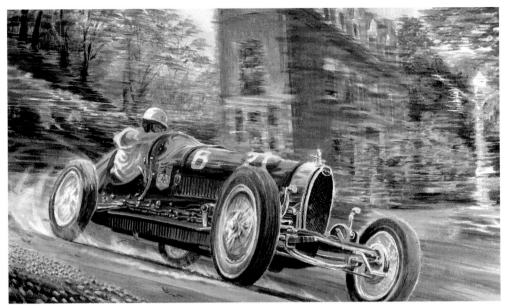

Bill Milliken lost control in front of the flatiron building and flipped his Bugatti making the downhill turn toward Franklin Street in 1948. Milliken walked away from the accident and was still going strong 60 years later. Bob Gillespie caught the action just before the spill. Milliken's Corner is point seven in the aerial photograph on page 10. (Courtesy of Bob Gillespie.)

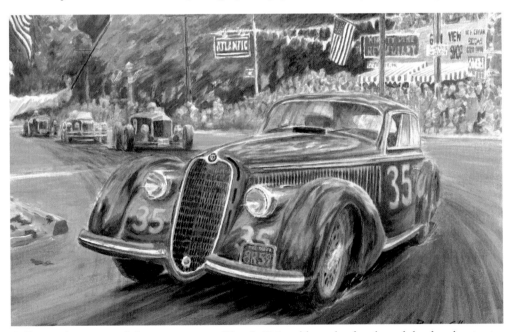

Gillespie also captured the excitement of Frank Griswold on the first lap of the four-lap junior prix in his supercharged 1938 Alfa Romeo 8C-2900B. Behind him are Briggs Cunningham in a Bu-Merc (a custom Mercedes body with a Buick Century chassis) and George Henrie in his 1928 Alfa Romeo 6C-1750. (Courtesy of Bob Gillespie.)

Dave Garroway, who became the first host of the original *Today* show, raced his Jaguar SS100 in 1949. Standing at right, from left to right, are Kurt Boehm and John Cuccio of Studebaker Styling; J. Fred Muggs is unaccountably missing. The location is just past the Stone Bridge. Garroway raced the same car in 1950 at Watkins Glen.

This 1938 Alfa Romeo 8C2900B "S" 2.9 liter, driven by Mal Ord, swings through the Esses just past the Stone Bridge in the 1949 race.

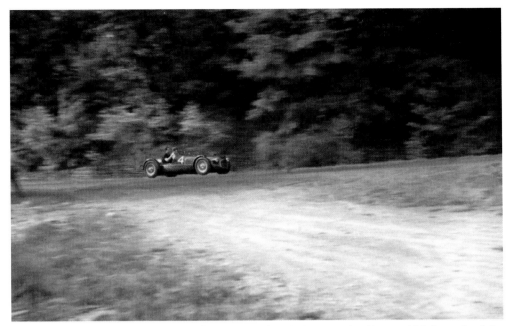

Briggs Cunningham takes a practice lap prior to the 1949 race in his Ferrari 166. In each of the first three years, Cunningham finished second.

Phil Walters (left) and John Fitch are seen here in 1951 after Walters won the Grand Prix in a Cunningham C2R, and Fitch came in second place, driving the same car. They were superb performers at Watkins Glen and elsewhere throughout their careers. Fitch later drove for the Mercedes-Benz factory team.

Max Hoffman had the first Jaguar XK in America.

The Sports Car Club of America held a joint meeting of its contest board and activities committee at Washington, D.C., in February 1950. The Watkins Glen race was a leading event, and several in attendance were prominent competitors. From left to right are Smith Hempstone Oliver, curator at the Smithsonian Institution and announcer for the original races in 1948; Reginald Smith; Alec Ulmann; Russ Sceli; Nils Mickelson, long-term starter for the races; George Weaver; Miles Collier; and William F. Millken Jr. In the Healey Silverstone is Cameron Argestinger.

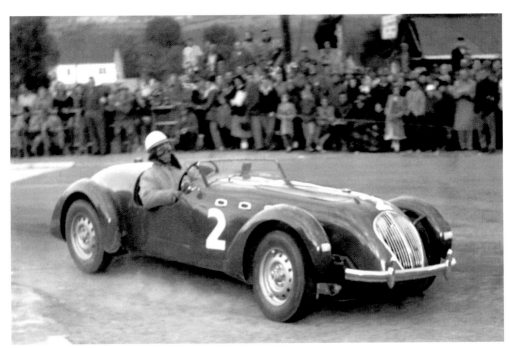

Cameron Argetsinger raced in several of the early meets. He is seen here at the 1950 Grand Prix race driving a Healey Silverstone, making the turn from Franklin Street onto Old Corning Hill.

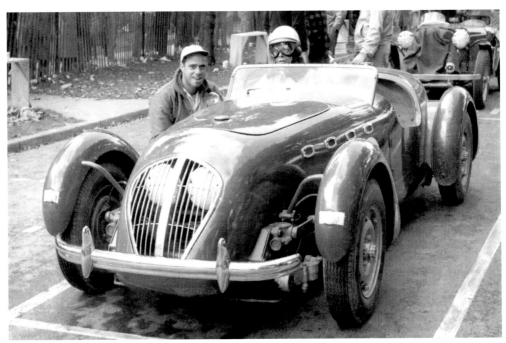

Though never emerging victorious, Argetsinger must have derived considerable satisfaction from participating in addition to being the organizer. He is seen here in 1950 with his mechanic Tony Wineburg.

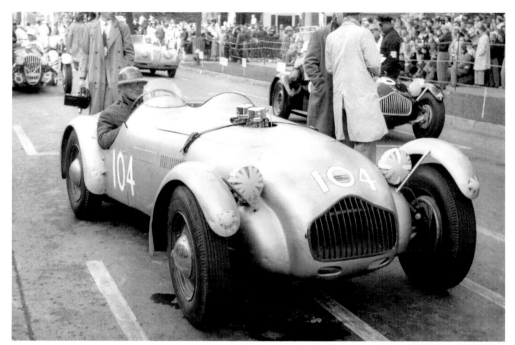

Tommy Cole is on the starting grid for the 1950 grand prix in his Cadillac-Allard. While previous races had been started with a green flag, the 1950 starter used an American flag to recognize the international character of the competition.

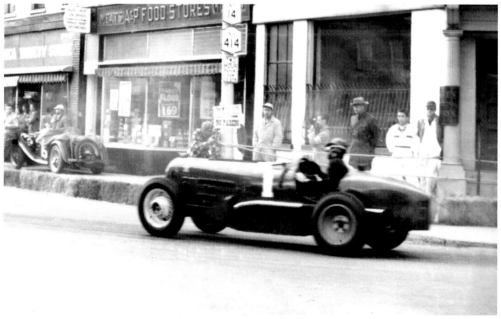

Miles Collier is coming along Franklin Street for the 1950 grand prix in his Ford-Riley "Ardent Alligator." He took the 1949 grand prix in this vehicle. Notice the MG on the sidewalk in front of the A&P.

THROUGH THE STREETS

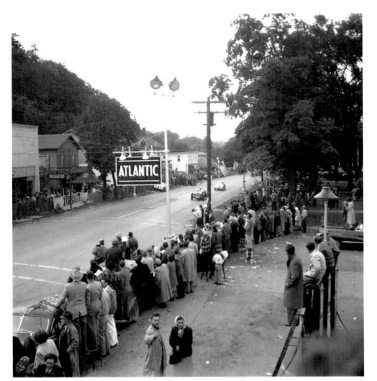

In the No. 6 Alfa Romeo, George Huntoon is leading John Fitch in his No. 85 Fitch-B Special in 1950.

Dave Garroway's No. 103 Jaguar SS-100 has the street to itself for the moment in the 1950 Grand Prix race.

The No. 1 Ford Riley, driven by Miles Collier, is seen here at the 1950 Seneca Cup race. Collier finished third overall.

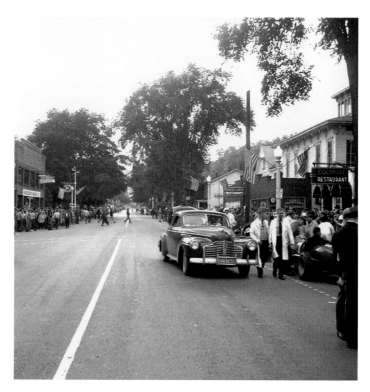

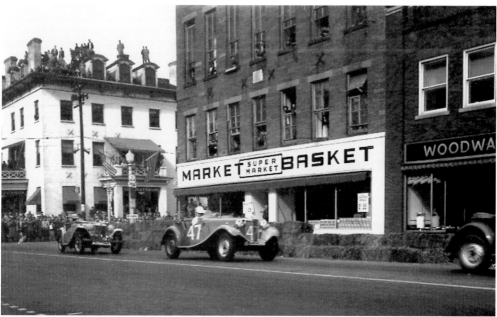

Gus Ehrman's No. 47 MG TD and George William (Bill) Fleming's No. 18 MG TC have just descended the hill and made the 90-degree turn onto Franklin Street. Notice the spectators crowding the roof, porches, and gables of the since-vanished Jefferson Hotel at left. Notice also the prices in the supermarket.

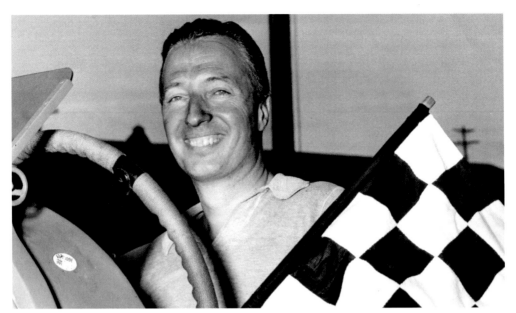

Miles Collier's brother Sam (shown here) lost his life in the 1950 grand prix, flipping his Ferrari 166 just beyond the railroad underpass, which can be seen in the aerial photograph on page 10 and the map on page 2. Both brothers were founders of the Automobile Racing Club of America.

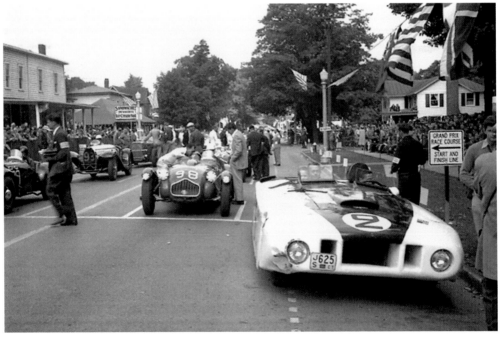

Driving the No. 2 car for the 1950 Seneca Cup pace lap is Cameron Argetsinger, with son J. C. and father James next to him. Nearby are Erwin A. Goldschmidt's No. 98 Cadillac-Allard J2, Robert Grier's No. 97 Cadillac-Allard J2, and Hal Ullrich's No. 93 Bugatti.

Ullrich, in a Bugatti, looks ready for anything, but Grier is getting some last-minute attention. In the No. 3 Maserati RI is George B. Weaver.

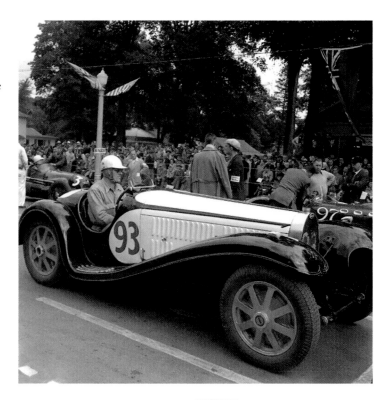

Weaver looks as though he is planning nothing more strenuous than a pleasant drive in the country. But he won the Seneca Cup the following year in his 20-year-old Maserati and the Queen Catharine Cup in a Jowett Javelin Jupiter. Behind him is Lt. Elliot C. Tours, No. 34 MG TC.

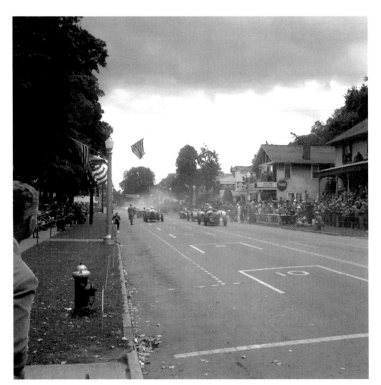

The 1950 Seneca Cup pace lap is on its way with the crowd straining to look after the racers.

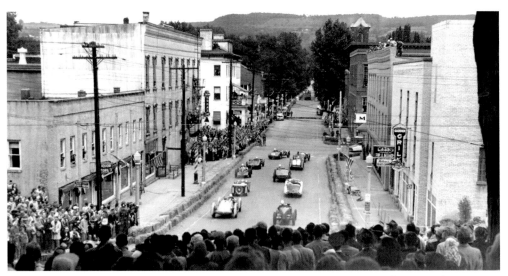

Scattered throughout this 1950 Seneca Cup pace lap are Jean Davidson in the No. 79 Cadillac-Allard J2, Erwin Goldschmidt in the No. 98 Cadillac-Allard J2 leading the left column, Hal Ullrich in the No. 93 Bugatti, Elliott Tours in the No. 34 MG TC, Robert Grier in the Cadillac-Allard J2, Arthur Hoe in the No. 53 Duesenberg, George B. Weaver in the No. 3 Maserati RI, Robert Wilder in the No. 66 Ladd-Ford Special, John Fitch in the No. 88 MG RC-Lagonda, and an unidentified driver in the No. 72 XK120 Jaguar. Just visible going around the corner to the right is the tail of a Cadillac Le Monstre with Cameron Argetsinger driving.

Now the 1950 Seneca Cup race is under way.

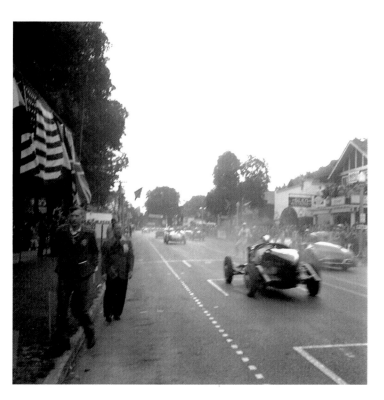

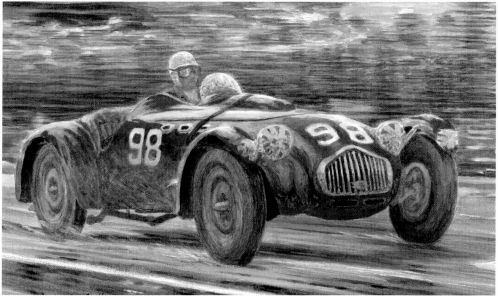

Besides being marred by the death of Sam Collier, the 1950 meet was controversial for Argetsinger's insistence on admitting Goldschmidt to the competition. Many racers felt that he was too professional, and, though it may have been unspoken, perhaps too Jewish for some of them. Goldschmidt certainly proved that he was excellent, galloping to victory in the 15-lap grand prix and to second in the 15-lap Seneca Cup race. (Courtesy of Bob Gillespie.)

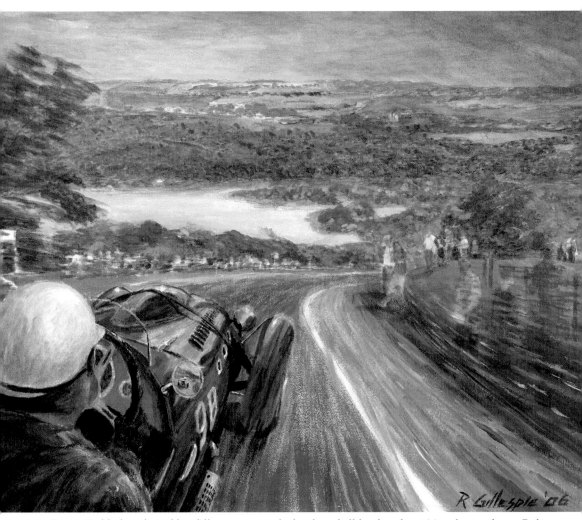

Erwin Goldschmidt and his fellow racers took the downhill big bend at 100 miles per hour. Bob Gillespie's view of the 1950 race shows rain clouds gathering. The clouds soon wet the road surfaces, adding yet another factor to the drivers' calculations. (Courtesy of Bob Gillespie.)

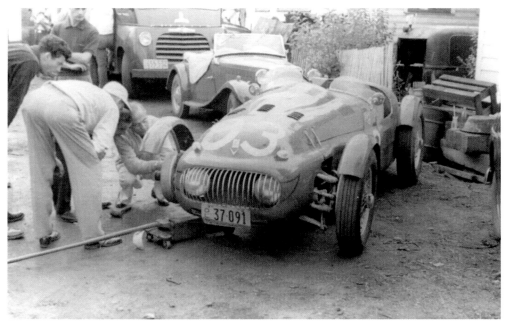

Car No. 93, Harry Grey's Nardi-Cadillac special, appears to be getting some brake work done. It must be a complicated job to require four consultants for one mechanic.

Brett Hannaway and his Maserati seem to have gotten into some trouble during practice for the 1952 Seneca Cup. He looks determined but in the end did not race.

THROUGH THE STREETS

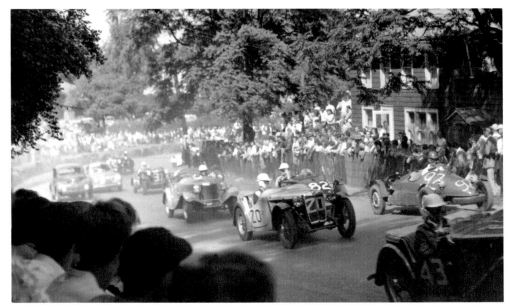

These cars must have made quite a sound rumbling up Old Corning Hill in the 1951 Queen Catharine's Cup race, and they certainly made for a glorious picture. Identifiable here are Robert Keller in the No. 60 Fiat 1100S, James W. Ferguson in the No. 68 FM Morris, William B. Lloyd in the No. 30 MG TD, John Gordon Bennett in the No. 100 MG TD, Frank O'Hare in the No. 20 MG TD, Marsh C. Thomas in the No. 82 MG Special, Kurt Hildebrand in the No. 92 VW Porsche Special, and Peter J. Crocker in the MG TC.

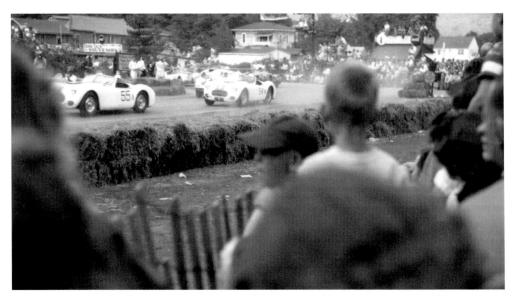

Seen here are No. 55, a Cunningham C2R driven by Phil Walters, who won the race, and No. 54, a Cunningham C2R driven by John C. Fitch, who would finish the race second overall. Notice that the spectators at this vantage point just after the start-finish line in the 1951 race are held back by snow fences, separated from the racers by a wide space and a hay-bale rampart.

Overlooking a sharp turn as it did, this was clearly a popular and exciting location for spectators as the cars started up Old Corning Hill. Coming through in the No. 42 Ferrari 166 Inter from Briggs Cunningham is Jim Kimberly, who finished 10th in this 1951 grand prix. Cunningham himself finished second with the same vehicle in 1949, while the car carried Sam Collier to his death in 1950.

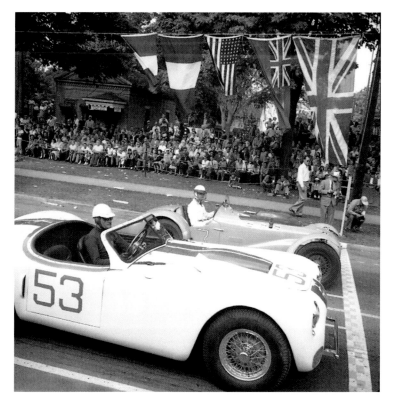

Cunningham, in his Cunningham C2R, and George R. Harris III in the No. 3 Cadillac-Allard J2 await the 1951 start. This same scene today is shown in the photograph on page 121.

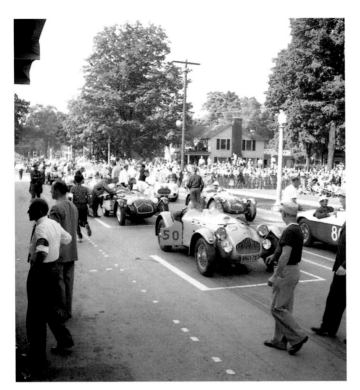

Notice the state trooper on the left, the several officials with armbands, and the crowd back behind snow fencing to the right in 1951.

Another view from 1951 shows Briggs Cunningham with his No. 53 Cunningham C2R, standing at the right behind his car; William C. Spear in the No. 86 4.1 Ferrari America; Brett E. Hannaway in the No. 50 Cadillac-Allard J2; and Joe B. Sabal Jr. in the No. 48 Chrysler-Allard.

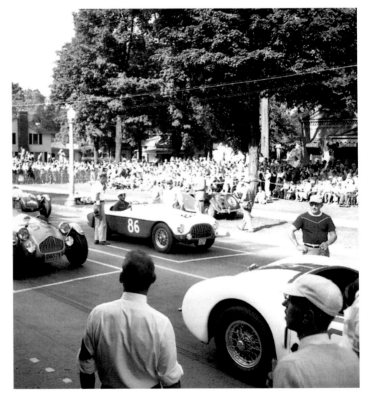

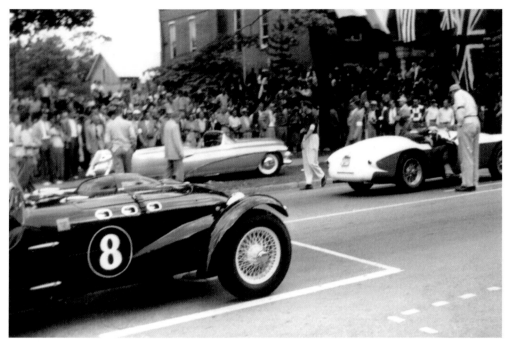

In 1951, at the start of the race outside the Schuyler County courthouse, is Fred Wacker's Cadillac-Allard J2 "Crazy 8." Wacker was later president of the Sports Car Club of America.

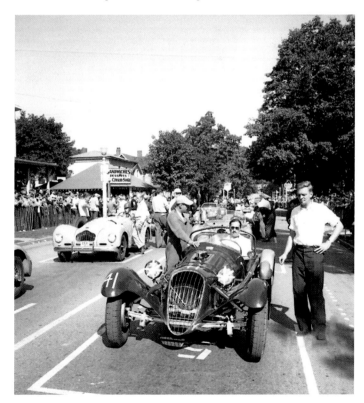

This scene captures the village, the crowd, the racers, and the course, not to mention the tension, all at once. At right is John Bentley's Cadillac-Meyer. No. 81 is Fred Fredzed's Chrysler-Allard.

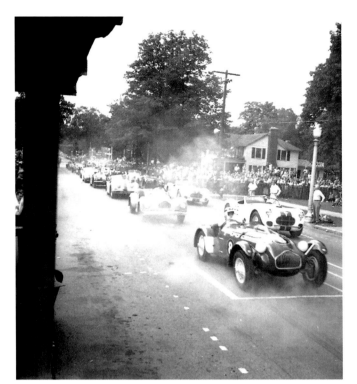

Getting closer to a start, the engines are revving.

The rear of the field is finally getting off the mark.

NO
PARKING
2.00 AM
TO
5.00 AM

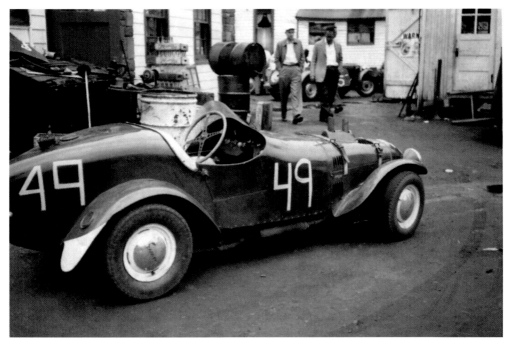

George Schraft (above) and Dr. Gandolph Vilandi (below) drove Crosleys in the 1951 Queen Catharine Cup race.

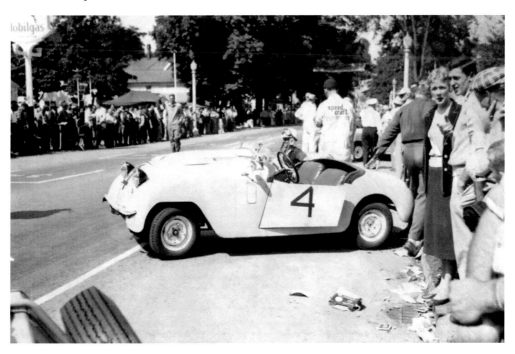

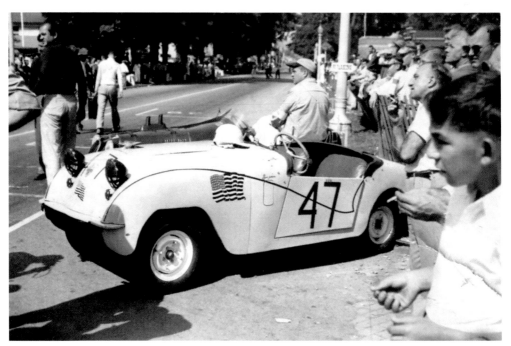

Steve Lansing also drove a Crosley.

Of course, the MG was ever popular.

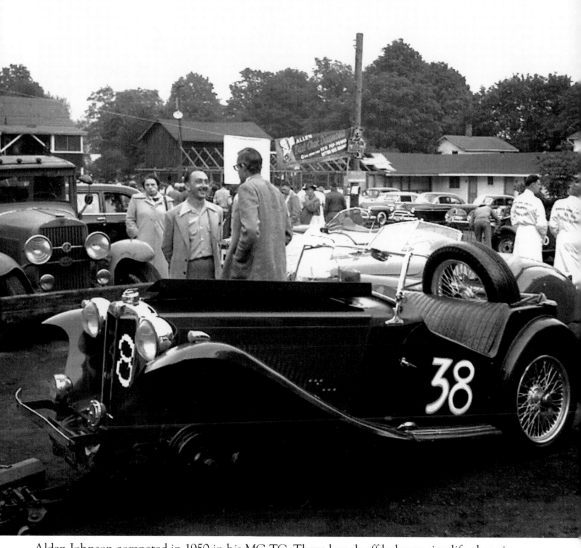

Alden Johnson competed in 1950 in his MG TC. Those knock-off hubcaps simplify changing a tire. Pictured in the background with the mustache is George Weaver.

Alfred Cooper had a special-bodied MG TC in the 1951 race. The photographer has done a delightful job of focusing on the car and still preserving the fact of speed.

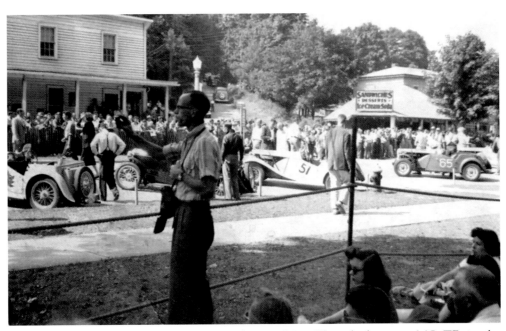

Chester C. Hawley (No. 51) and Gus O. Ehrman (No. 65) each drove an MG TD in the 1951 Queen Catharine's Cup race. Ehrman won the 1954 Collier Brothers Memorial race at Watkins Glen in an MG TD. The photographer in the foreground appears to be checking his light meter.

That may be an MG on the shield for the communications committee. Its work would need to be meticulous for safety's sake.

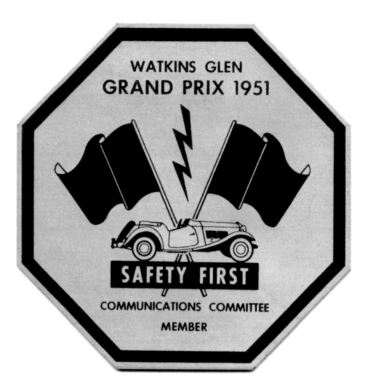

Phil Walters drove a Cunningham C-2 to victory in the 1951 grand prix. In 1954, on the new road course in Dix, he won the Sports Car Grand Prix in a Cunningham C4R.

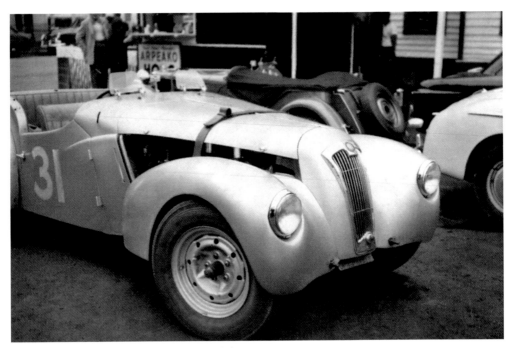

Arthur Iselin drove a Lea-Francs automobile.

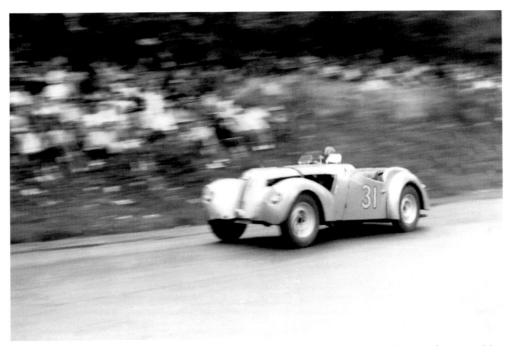

Here Iselin takes Old Corning Hill in the grand prix. The crowd in the background is just a blur as the photographer panned his camera.

George B. Weaver's Jowett Javelin Jupiter is getting a little loving attention.

The attention must have helped. Weaver drove No. 15 to victory in the 1951 Queen Catharine's Cup race. All in all, Weaver won four times at Watkins Glen.

The handwriting of the future was already on the wall in 1951, with several vehicles of minimalist design in the races. Seen here is a Formula III car.

John Fitch drove a Cunningham C-2 in the 1951 grand prix.

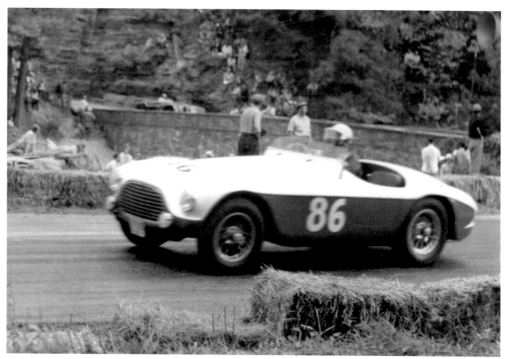

Bill Spear finished third in the 1951 grand prix with his blue-and-white Ferrari 340 "America."

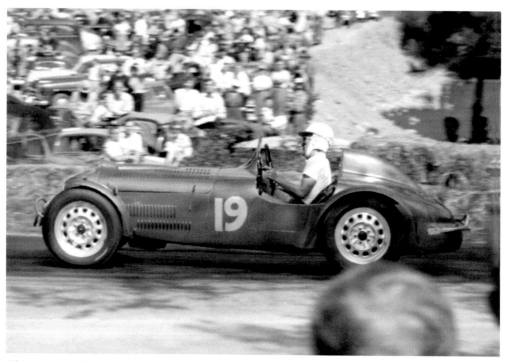

This Lester MG Special carried David Viall to second place in the 1951 Queen Catharine Cup race.

Al Coppel finished 25th in 1951 with a red-and-silver MG Special.

Charles Moran came in 14th in the 1951 grand prix, racing a Ferrari 166 mm.

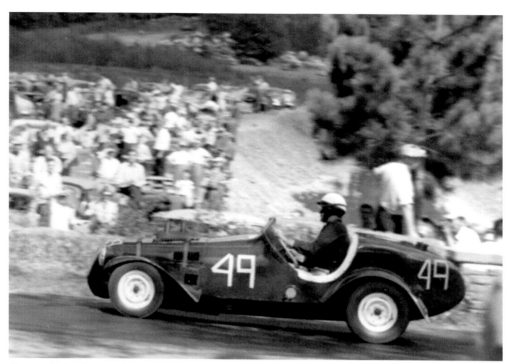

George Schraft's Crosley Hot Shot came in 30th at the 1951 grand prix.

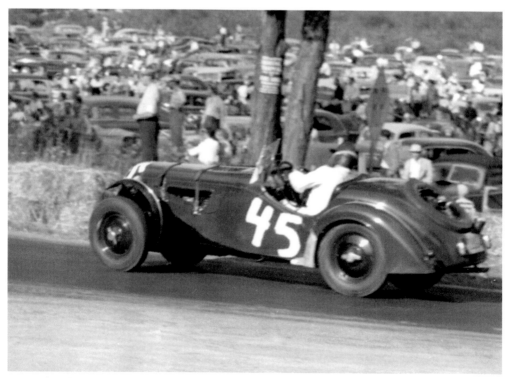

E. J. Tobin finished the grand prix 17th in 1951 with a little help from this BMW.

An excited Irving Otto Linton drove a Siata for the 1951 Queen Catharine's Cup race.

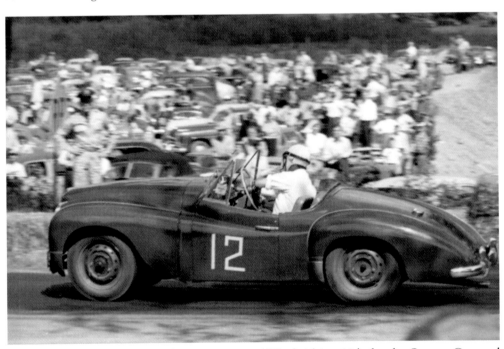

Hugh Byfield raced his Jowett Jupiter twice in 1951, finishing 14th for the Seneca Cup and 28th in the Queen Catharine Cup race. Until 1951, some races at Watkins Glen, including the Queen Catharine's Cup, used a Le Mans start, with drivers sprinting to their cars.

This picture is a reminder of why the original course at Watkins Glen was so thrilling. Fred Proctor in his No. 91 Siata Diamond coupe is heading for the Stone Bridge in 1951's Queen Catharine Cup race. He finished in 12th place. Linton is chasing Proctor with the No. 33 Siata Crosley.

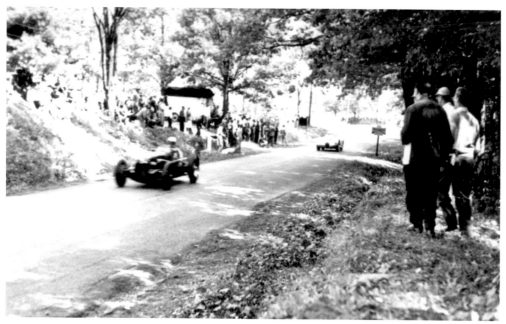

A race under autumn leaves on a crisp, sunny day had to be unforgettable. Here George Weaver leads John Fitch in the 1952 Seneca Cup race at Old Corning Hill. Fitch is driving a C-Type Jaguar.

THROUGH THE STREETS

Spectators must have felt that the race was unforgettable. Look how many are crowded on the porch roof of the house in the upper center. That may be William C. Spears's No. 82 Osca parked across the street. Notice the official carrying a checkered flag behind the car.

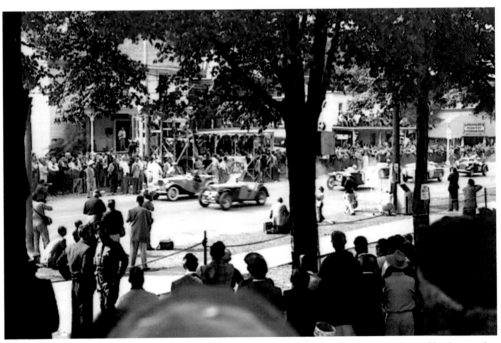

Those who were there in the early days still eagerly recount their memories, especially those who viewed the race from the start-finish line as these people did. Car No. 7 is most likely Denver Cornett's MG TC. This photograph was taken around 1952.

Local residents and visitors of all ages from around the globe shared the excitement. Sports cars on both sidewalks are getting careful inspection. Something off to the left is seizing people's attention.

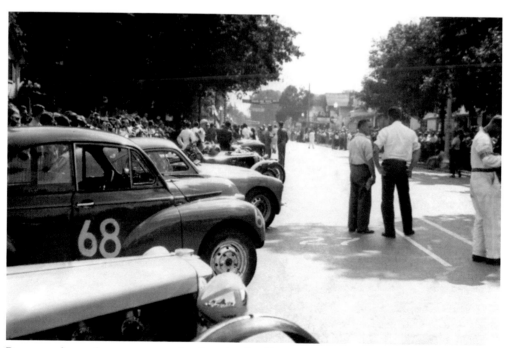

Racers and crowds got to see each other closely. The street-racing days at Watkins Glen had a very personal feel to them. Even into the 1960s, with a purpose-built track in use, drivers often stayed in local homes and garaged their cars with accommodating villagers.

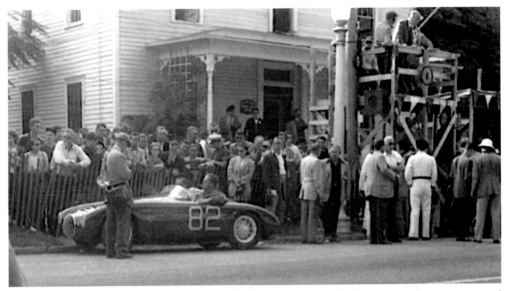

Bill Spear's No. 82 Osca won the 1952 Queen Catharine Cup race. Look at the platform constructed for official observers. Compare that with the tower on page 63.

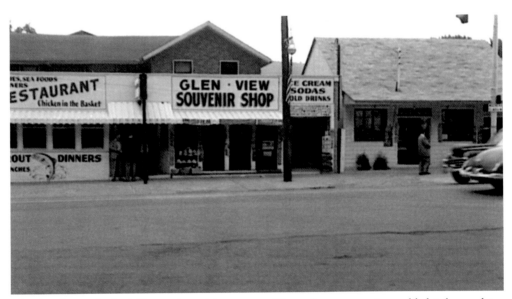

The facade is a little different, but visitors can still purchase souvenirs, cold drinks, and ice cream here across from the entrance to the state park.

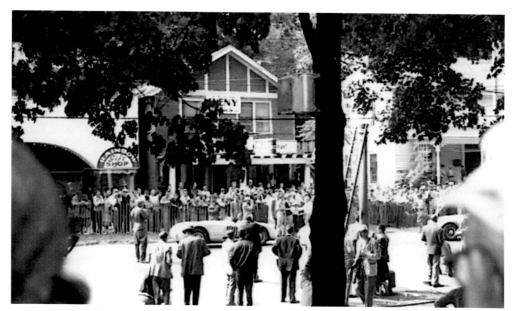

WENY was the first radio station in Elmira and one of the first in the region. Originally licensed in 1932 as WESG (named for one of the owners, the Elmira *Star-Gazette*), the station changed its name in the 1940s and is now known as WENI. At the time this photograph was taken, it broadcast from the top floor of the Mark Twain Hotel in Elmira.

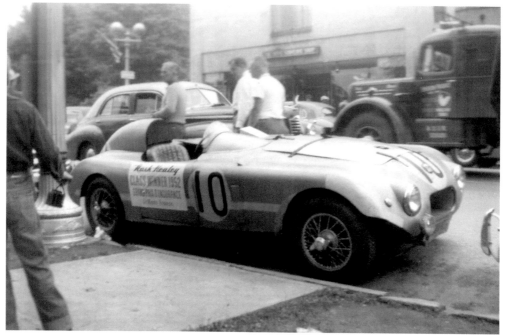

This vehicle took an award for superior endurance in 1952. However, Nash automobiles did not fare as well.

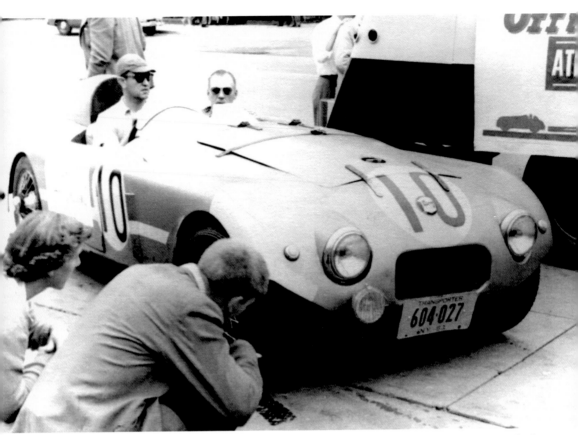

All the vehicles in the street-racing days got plenty of up-close-and-personal attention. With the cost of pit passes today, it is an expensive proposition to view the cars closely.

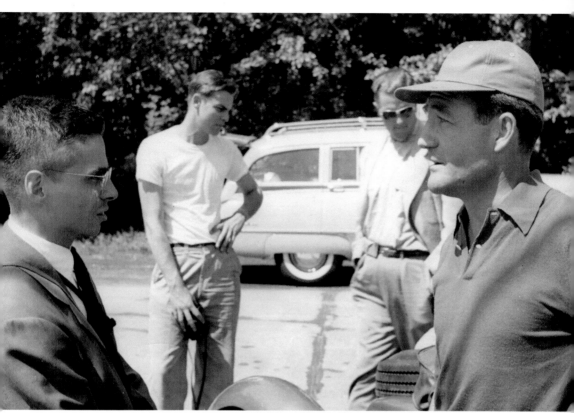

Pictured are two important figures in Watkins Glen's early days. Cameron Argetsinger (left) was the founder, course planner, and frequent competitor in Watkins Glen racing; Briggs Cunningham was never a victor, but he was a three time second-place finisher and a highly successful automobile designer.

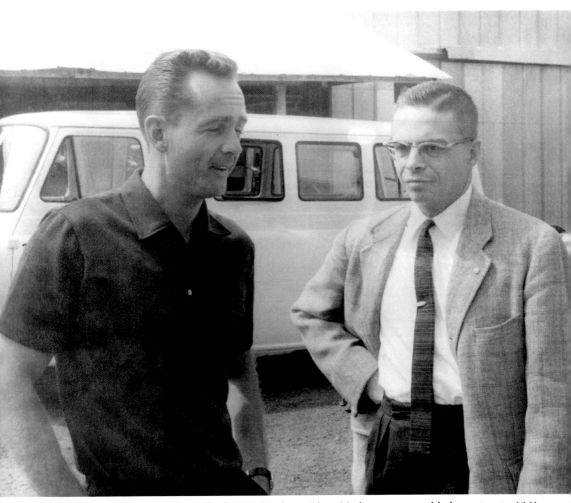

Phil Hill (left) raced in the early days at Watkins Glen. He became a world champion in 1961. He is shown here in conversation with Argetsinger.

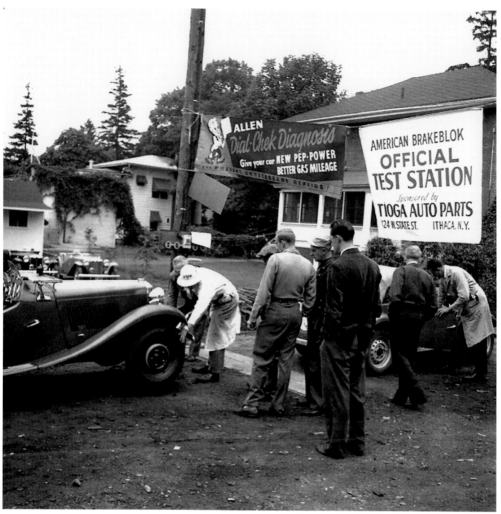

Specialized brake testing also took place at Smalley's Garage. It must have been specializing in MGs when this photograph was taken.

This Cunningham C2R is at the local Ford dealer's garage.

When the engine, drive system, and aerodynamics receive such exhaustive attention, there is little enthusiasm left over for the driver's space. Even so, this one is far less spartan than many. Notice the helmet on the right.

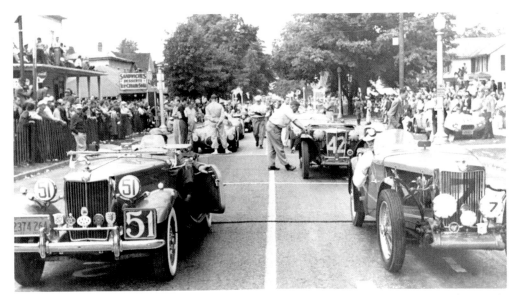

On the starting grid for the 1952 Queen Catharine's Cup race were Ben F. Harris in the No. 51 MG TD, Denver Cornett Jr. in the No. 7 MG TC, James Puckett in the No. 42 MG TC, and directly behind Harris is William C. Spear in the No. 82 OSCA. This race honored Seneca Nation leader Catharine Montour and her home at what became the nearby village of Montour Falls. Only vehicles with engine displacements up to 1,500 cubic centimeters competed.

C. Gordon "John" Bennett is ready for racing in 1952 with his supercharged MG TC. Supercharged vehicles had to compete one class above their native level.

In 1952 at the Seneca Cup. William F. Milliken Jr. ran an FWD/A. J. Butterworth Special. They obviously were not competing in a beauty contest.

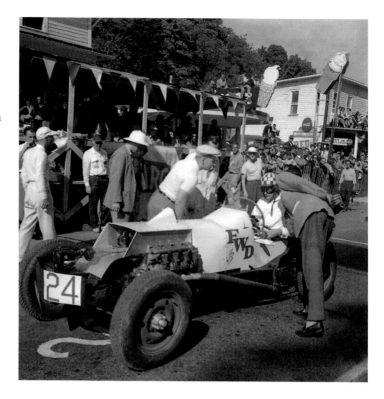

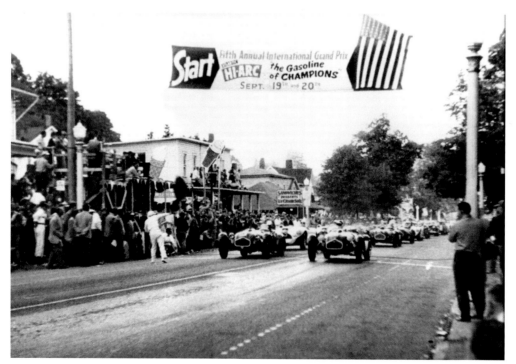

The 1952 race begins with no hint of the tragedy ahead.

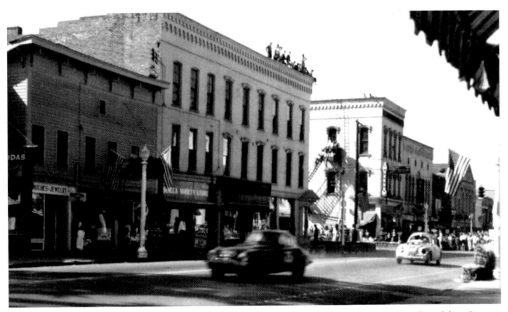

These vehicles are just regaining speed after making the 90-degree turn onto Franklin Street, entering the final straightaway for each lap. This is just after point seven in the aerial photograph on page 10.

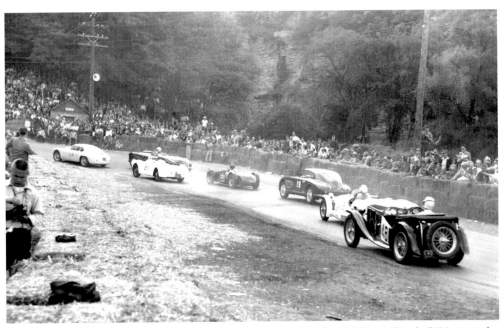

On their way in the 1952 grand prix are Otto Linton in the No. 114 Siata, Frank O'Hare in the No. 95 Nash-Healey, E. J. Tobin in the No. 21 BMW, S. R. Soulas in the No. 28 Maserati, Bob Gegen in the No. 19 Aston-Martin, Ralph Knudson in the No. 123 Excalibur J, and Charles Dietrich in the No. 48 MG TC.

WATKINS GLEN RACING

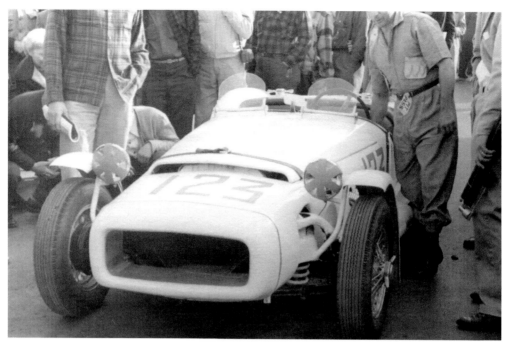

Knudson's up-to-date Excalibur J is getting plenty of attention. Notice the coil spring by the left front wheel not to mention the pit pass tagged to the belt, and the bloused trousers.

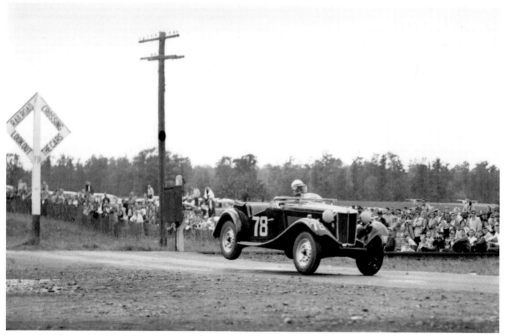

John Plaisted and his MG TD are almost airborne in the 1952 Queen Catharine's Cup race. Plaisted is clearing the railroad crossing (point five in the aerial photograph on page 10) heading for Friar's Corner and the Big Bend (point six).

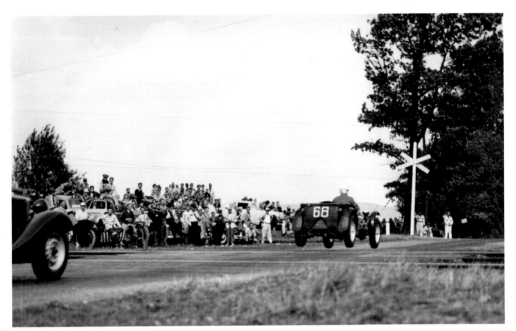

Robert Hitchcock in his MG TC is crossing the tracks and approaching a flagman (far right) in the 1952 Queen Catharine's Cup race. This is a straight stretch well outside the village limits, but the spectators are still mighty close.

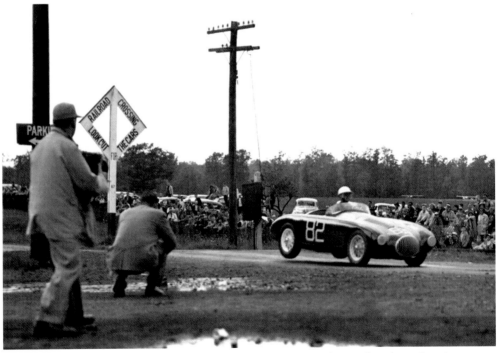

William C. Spear carried off Queen Catharine's Cup in 1952, flying after the railroad crossing. This location today can be seen on page 124.

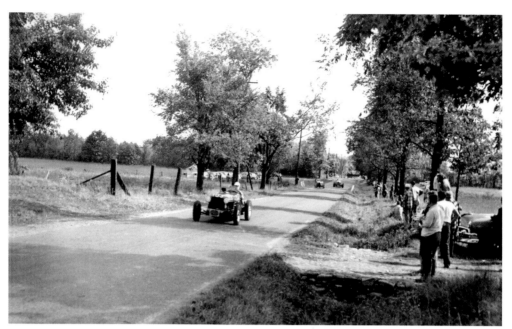

Here comes Fred White chasing the 1952 Seneca Cup in his Ladd Special. Roaring up behind is Sherwood Johnson in his No. 106 Lagonda Chrysler Power D.

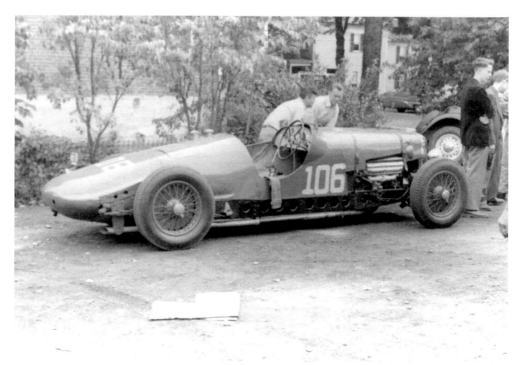

The Lagonda Chrysler Power D has a no-frills cockpit.

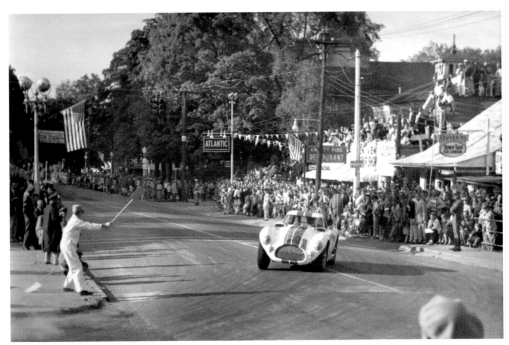

Phil Walters, in the No. 1 Cunningham 4RK, takes practice laps prior to the 1952 grand prix. Walters had number one because he was the defending champion from the previous year.

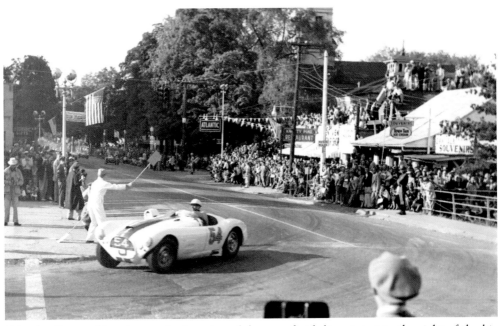

Schuyler County Courthouse, the location of the start-finish line, is just to the right of the big tree as John Fitch, in the No. 54 Cunningham C4R, makes the turn in one of three practice laps leading into the 1952 grand prix. Behind Fitch are Fred Wacker in the No. 8 Cadillac-Allard J2 "Crazy 8" and George Harris in the No. 3 Cadillac-Allard J2.

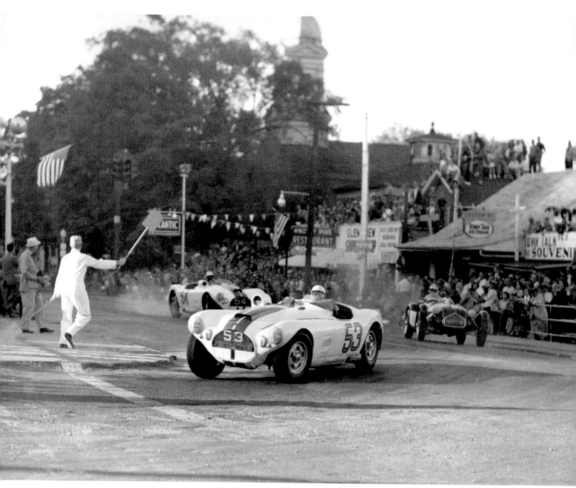

Innocence ends at Watkins Glen. Briggs Cunningham, in the No. 53 Cunningham C4R, was leading at the end of the first lap in the 1952 grand prix when Fred Wacker, in the No. 8 car (right), attempted to pass John Fitch in the No. 54 car. The race had been running late, and idling spectators crowded too close to the street. Wacker, without even feeling the impact, brushed into the crowd. Notice the spectators and the flagman at left, peering into the crowd across the street behind the vehicles.

THROUGH THE STREETS

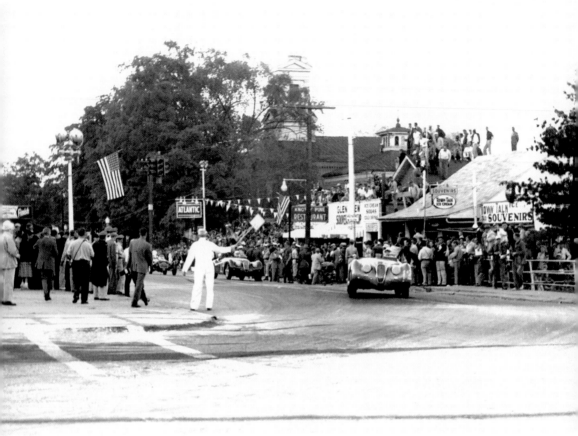

Seconds later, the race, and all street racing in Watkins Glen, was ended, never to resume. Twelve people had been injured, and seven-year-old Frankie Fazzary was killed. New York Metropolitan Opera tenor James Melton, a dedicated racing fan, soon took the microphone and united the stunned crowd, singing "God Bless America" and "Ave Maria." A tearful Fred Wacker, at the funeral, assured Fazzary's father that he would never race again.

WATKINS GLEN RACING

2

DOWN THE ROADS AND AROUND THE TRACK

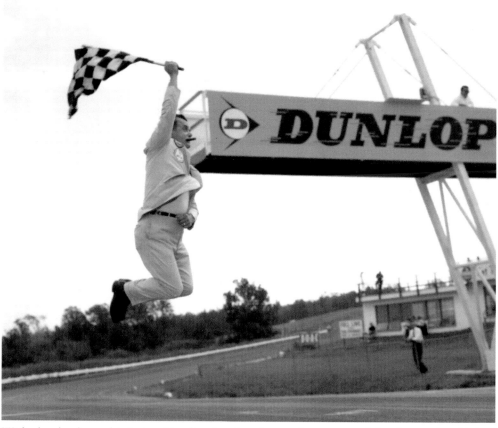

With the deaths and injuries, Lloyd's refused to insure the meet, and the Sports Car Club of America dropped sponsorship. But the race was on again in 1953 with a new 4.6-mile course over rural roads nearby Townsend, New York, in the town of Dix. In 1956, a closed track arose on the site, echoing the original 1948 route. The new course had its ups and its downs. It also had world-class competitions, millions of spectators, and the greatest names in racing.

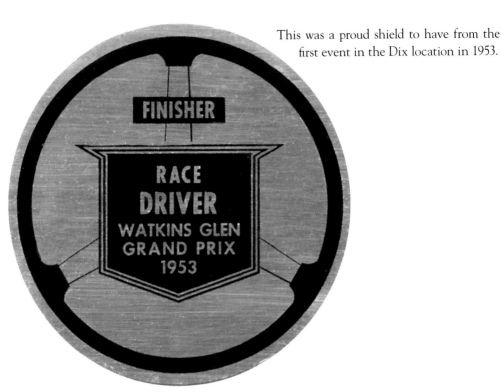

This was a proud shield to have from the first event in the Dix location in 1953.

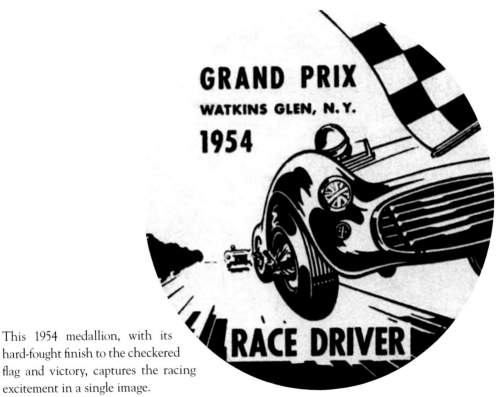

This 1954 medallion, with its hard-fought finish to the checkered flag and victory, captures the racing excitement in a single image.

The next year's medallion focused on the single-minded concentration needed for safe and successful racing.

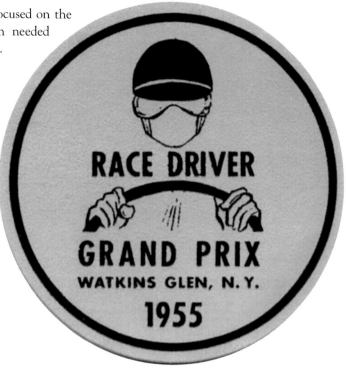

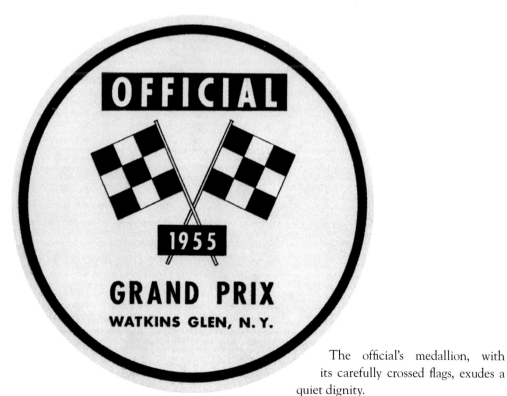

The official's medallion, with its carefully crossed flags, exudes a quiet dignity.

The new closed course was completed hours before practice started in 1956. Both the Sports Car Club of America and the Road Racing Drivers Club officially called upon competitors to boycott the race on the grounds that the uncured track was unsafe. Not one driver withdrew. J. H. Dressel competed in an A.C.E. Bristol.

Harold Ullrich's car was an Excalibur J. A veteran of the earlier street races, Ullrich finished third in the first grand prix at the new location.

INTERNATIONAL FORMULA LIBRE GRAND PRIX

OFFICIAL

1958

Watkins Glen Grand Prix Corporation

Formula Libre was sort of a free-for-all. Just about any type of vehicle could enter. This 1958 event marked Watkins Glen's initiation into professional sport car racing.

Coming along in the 1958 Glen Classic are W. P. Dalton in the No. 84 Corvette, an unidentified driver in the XK120 Jaguar, and Robert Lowman in the No. 107 Mercedes-Benz 300 SL.

DOWN THE ROADS AND AROUND THE TRACK

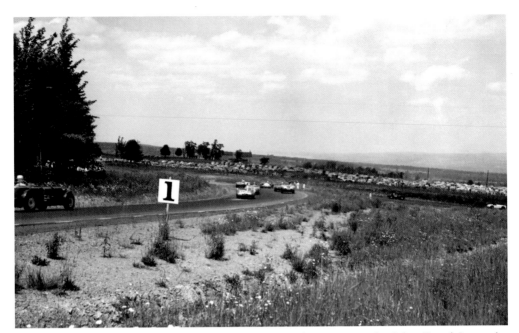

Spectators can appreciate the sweep of the Finger Lakes countryside. John Dowd Jr. in the No. 64 Jaguar Special, Robert Davidson in the No. 142 Lotus, and Jack Brewer in the No. 57 Ferrari have other things on their minds. They are doubtless keeping their eyes on the road.

Bill Sadler, in the No. 79 Sadler Special, and E. D. Martin, in the Ferrari 3.8, lock horns in the 1958 Glen Classic. The first Glen Classic run, the weekend of October 20–21, 1956, was won by Sadler over a now-cured track (the track was considered uncured for the September race).

The Sadler Special vehicles and the special Sadler skill led to frequent impressive showings.

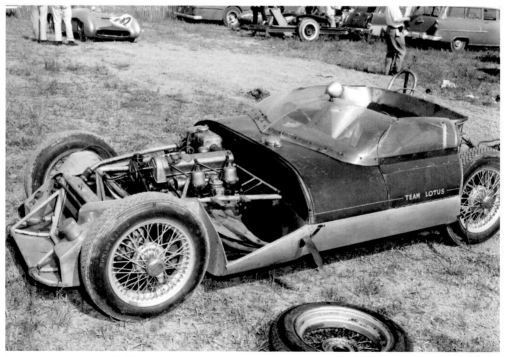

Thomas Schatchard's No. 4 Lotus was also in the 1958 Glen Classic. Here it is getting some overhaul.

Pushing drivers and vehicles to the limit was a risky proposition. George Morris's No. 74 Mercedes-Benz 190 SL came to grief in 1958.

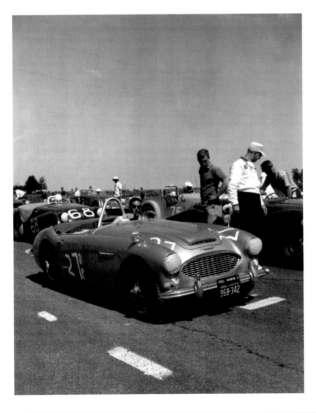

Tom Cullen, in the No. 27 Austin-Healey, and Richard Cosgrove, in the No. 68 Triumph, were competitors in 1958.

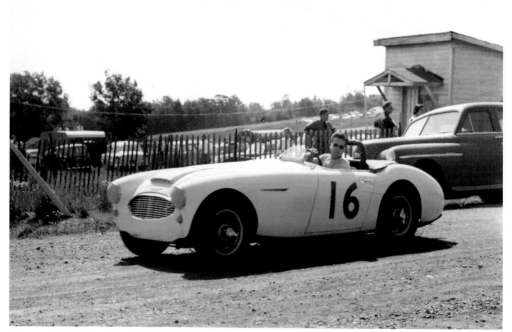

Norman Webb Jr. also had an Austin-Healey.

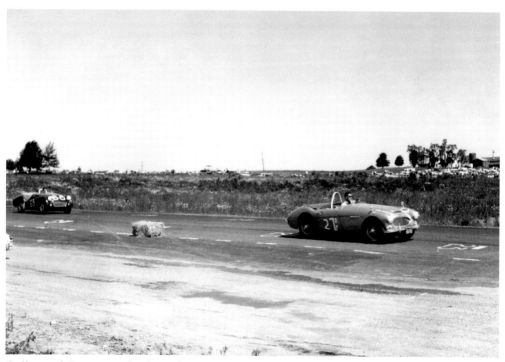

Cullen and Cosgrove take their places on the starting grid, recalling the old Franklin Street days that had started 10 years earlier.

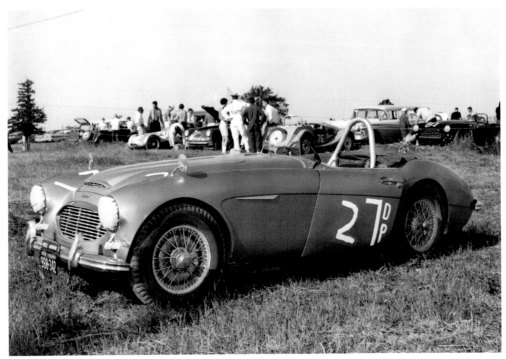

Even the new closed course continued the earlier air of informality for a time.

Chuck and Suzy Dietrich each drove the No. 96 Elva Mk. II in 1958.

Mike Webb checks his Cooper Mk. II Formula III machine in 1958. At right is Jack Paverling's No. 56 MGA.

Webb's Cooper is built around its engine, wasting not a gram of weight or a centimeter of space.

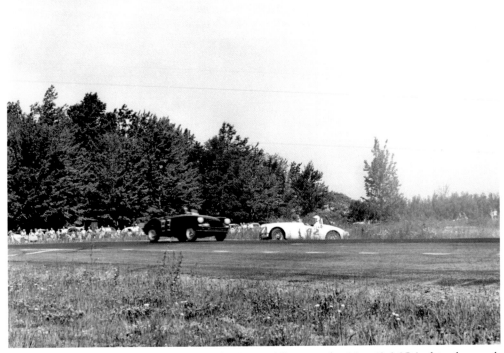

Jack Terhaar, in the No. 83 MGA, and Monty Allen, in the No. 42 MGA, hit the track in 1958.

GRAND PRIX OF THE UNITED STATES

WATKINS GLEN, N.Y. OCTOBER 3, 4, 5

PADDOCK

19 KENDALL 69
MOTOR OILS

NOT GOOD FOR GATE OR GRANDSTAND ADMISSION

From the very beginning, it had been Cameron Argetsinger's goal to host the Formula One U.S. Grand Prix at Watkins Glen.

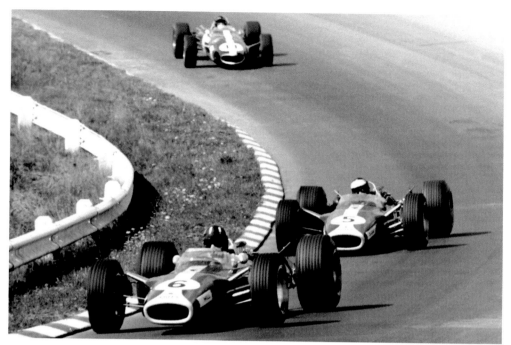

Formula One racing arrived at Watkins Glen in 1961 and continued until 1980.

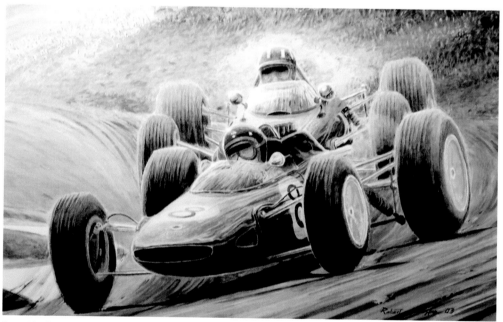

Jim Clark, in Colin Chapman's Lotus 25, and Graham Hill duel for position in Bob Gillespie's painting of the 1962 U.S. Grand Prix. Hill took the championship for drivers. Clark became world champion the following year. The two men shared early grand prix titles at Watkins Glen, with Clark winning in 1962, 1966, and 1967, while Hill carried off the trophy in 1963, 1964, and 1965. Clark later died in a German Formula Two race. (Courtesy of Bob Gillespie.)

DOWN THE ROADS AND AROUND THE TRACK

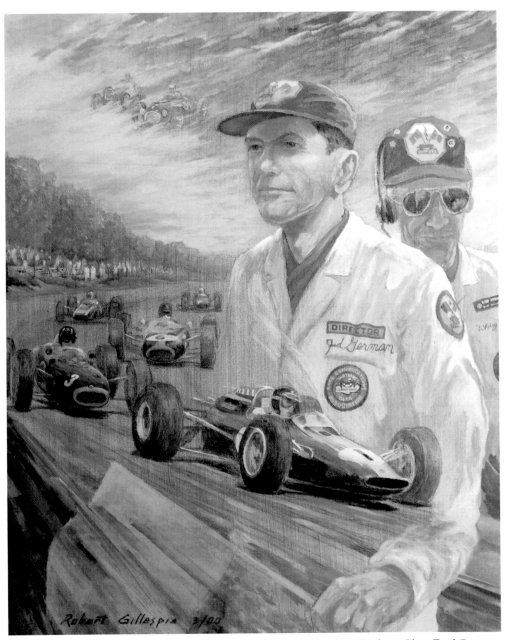

Searching for ways to enhance safety after Sam Collier's 1950 death at Watkins Glen, Fred German founded the Race Communications Association in 1951. Gillespie's commemorative painting shows German and Myron "Whitey" Bennett at a safety station for the 1962 U.S. Grand Prix. Jim Clark in the Lotus, Graham Hill in the BRM, and Dan Gurney in the Brabham race in the background. Sam and Miles Collier were added in the clouds. (Courtesy of Bob Gillespie.)

Cameron Argetsinger (lower left) holds the trophy for England's Graham Hill, who just won the 1965 Watkins Glen Grand Prix, averaging 107.98 miles an hour in high wind and driving rain. Hill drove a BRM. The Taylor wine came from Hammondsport, which lies one lake over from Watkins Glen and Seneca Lake.

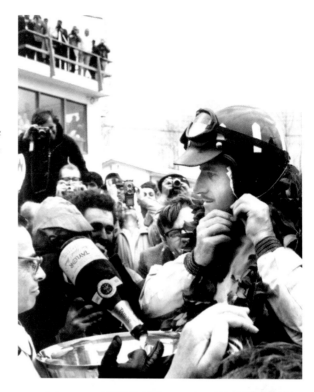

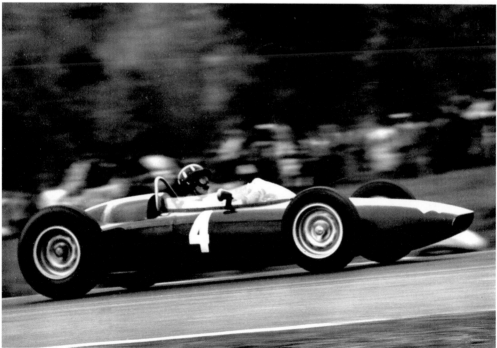

That 1965 victory for Hill was his third straight in the U.S. Grand Prix. He was badly injured in the 1969 U.S. Grand Prix when his Ford-powered Lotus cut a tire.

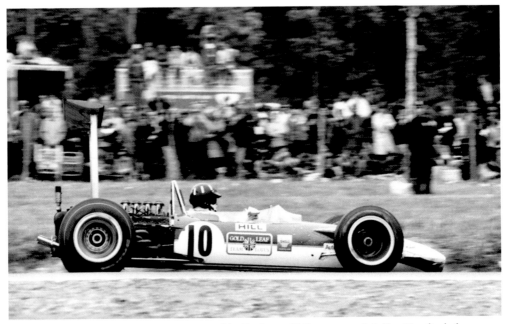

To the delight of the entire racing world, Graham Hill recovered fully. He died, however, in a private plane crash in England, November 29, 1975. He is seen here in the 1968 U.S. Grand Prix.

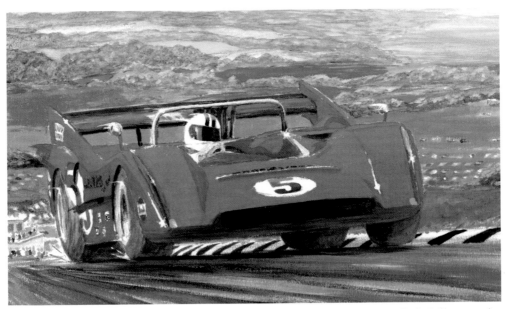

"This is one of the most scenic backgrounds in the racing world," says artist Bob Gillespie, who depicts Denis Hulme's M8-D entering the Esses on its way to victory in the 1970 Glen Can-Am. New Zealander Hulme won the race despite driving with hands that had been burned at Indianapolis that May. Hulme won the Glen Can-Am again two years later. Seneca Lake is in the background. (Courtesy of Bob Gillespie.)

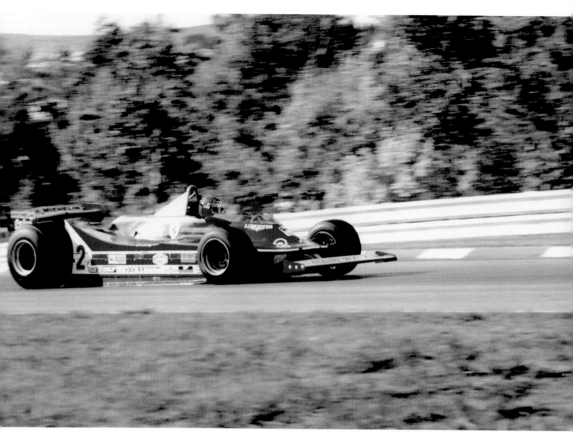

Canadian Gilles Villeneuve, who won the 1979 U.S. Grand Prix, tackled the 1980 race in a Ferrari. Villeneuve died two years later qualifying for the Belgian Grand Prix.

This Elva Courier appeared at a classic race in the late 1980s. (Photograph by C. R. Mitchell.)

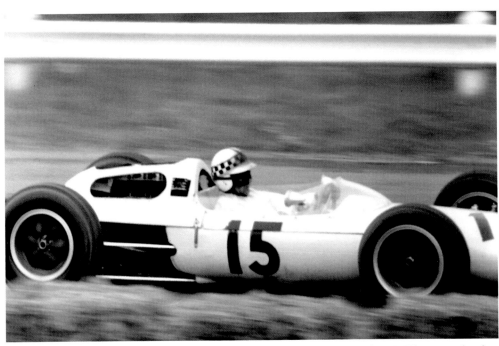

Scottish driver Innes Ireland won the 1961 U.S. Grand Prix on October 8. This was the first U.S. Grand Prix in Watkins Glen, the first factory Grand Prix victory for Lotus, and the championship Grand Prix win for Innes. This photograph shows the 1962 U.S. Grand Prix.

Here Ireland receives well-deserved congratulations.

The indestructible Bill Milliken had the honor of being chief steward when Watkins Glen hosted its first international grand prix in 1961.

DOWN THE ROADS AND AROUND THE TRACK

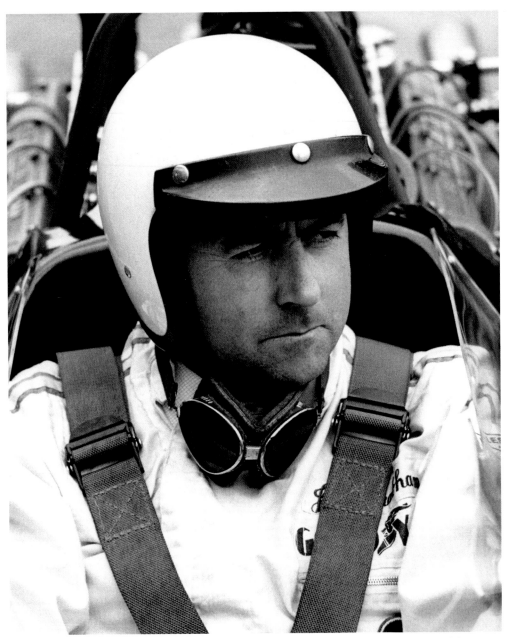

When Watkins Glen first secured the U.S. Grand Prix in 1961, Australian Jack Brabham was doing very well in a Cooper-Climax when he was forced out of the race by a water leak. He finished third in 1965 and second in the 1960 Formula Libre competition. His son Geoff later raced successfully at Watkins Glen as well.

Dan Gurney finished second in the first U.S. Grand Prix at Watkins Glen in 1961. This photograph of Gurney is from Europe in 1967, driving his own 3.0 litre V-12 Eagle-Westlake Formula One car.

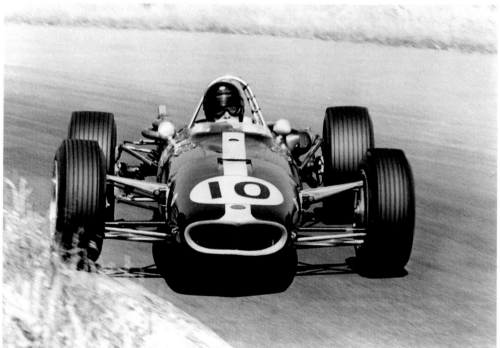

Gurney, here driving an Eagle at Zandvoort in 1966, finished fifth in the 1962 U.S. Grand Prix at Watkins Glen.

DOWN THE ROADS AND AROUND THE TRACK

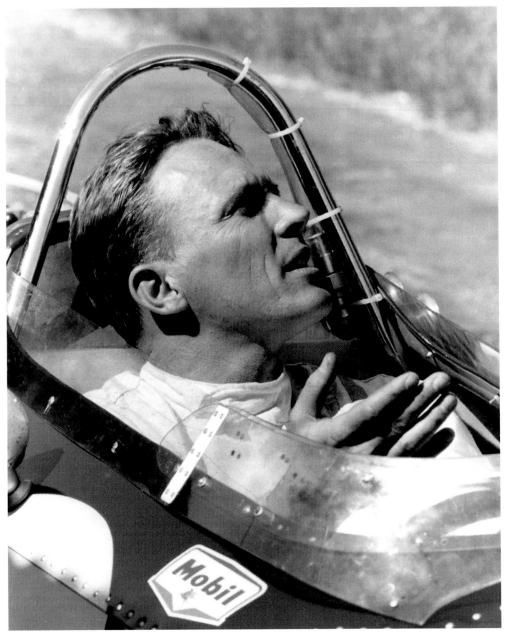

In another year, Dan Gurney drove an All American Racers Eagle with a 12 cylinder, three-liter Weslake Formula One engine.

Gurney (left) finished second in the 1958 Formula Libre race, while Sweden's Joakim Bonnier (second from left) came in first, and Bruce Kessler (right) was third. Bonnier died at Le Mans in 1972. Cameron Argetsinger is in the background.

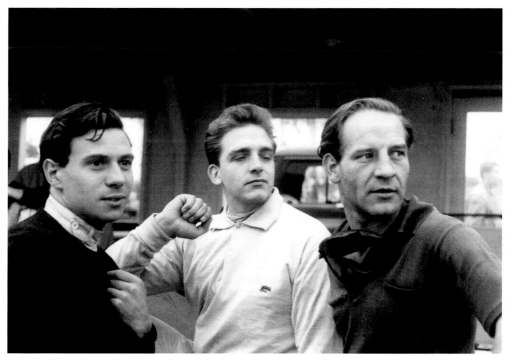

Jimmy Clark, Trevor Taylor, and Innes Ireland enjoy a peaceful moment at Watkins Glen. Ireland won the 1961 grand prix. Clark won in 1962, 1966, and 1967; he died the following year.

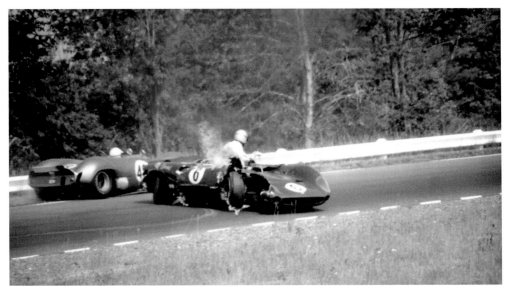

In the 1966 United States Road Racing Championship race, the Genie Mk. 10, shown on page 118, was involved in a collision that left it stranded on the track. Seconds later, Mark Donohue in the No. 6 Lola-Chevy clipped the Genie Mk. 10 and sent parts flying, forcing himself to the edge of the track after a wild ride. With great presence of mind, Donohue leapt from the car and sprinted for safety.

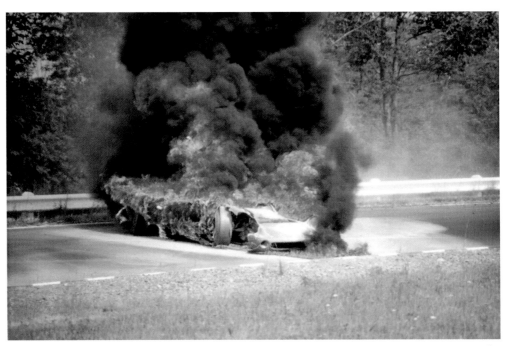

The vehicle went up in flames and was completely consumed, but Donohue went on to win the 1967 race. He also won the 1969 Trans-Am at Watkins Glen in a Camaro while racing for Roger Penske and the 1973 Can-Am in a Porsche.

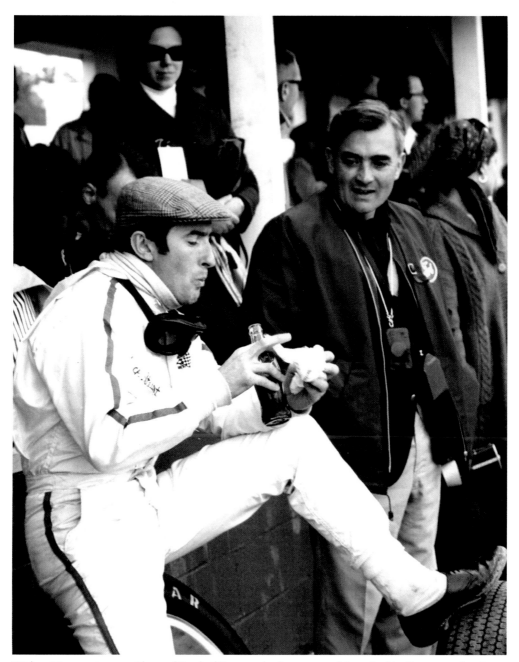

Walter Hayes, vice president of Ford of Europe, looks on as a thirsty Jackie Stewart gulps down a Coke. Stewart won the grand prix in 1968, leading the entire race in a Matra Ford. When the Scotsman won again four years later while driving a Tyrrell-Ford, he was piped into the victory circle.

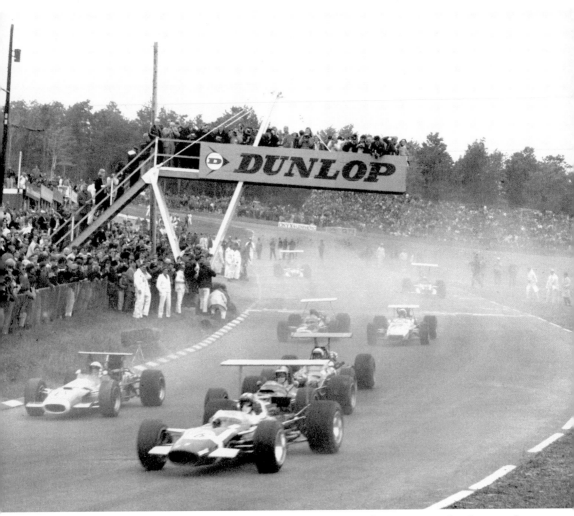

Starting off in a cloud of dust in the 1968 U.S. Grand Prix, these racers make their marks on the history of Watkins Glen.

Richard Petty raced in the 1964 NASCAR Grand National race and seven times in the Bud at the Glen.

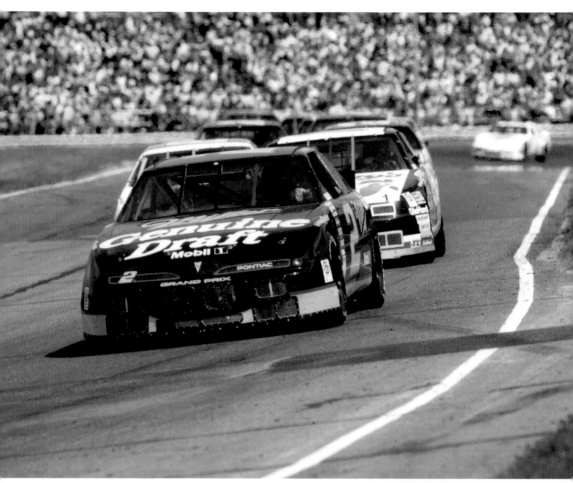

For many years, Budweiser's NASCAR Bud at the Glen Winston Cup race was one of Watkins Glen International Raceway's biggest attractions. NASCAR stock car racing at Watkins Glen became the biggest single-day sporting event in New York State. This 1993 image shows Rusty Wallace dueling for the lead.

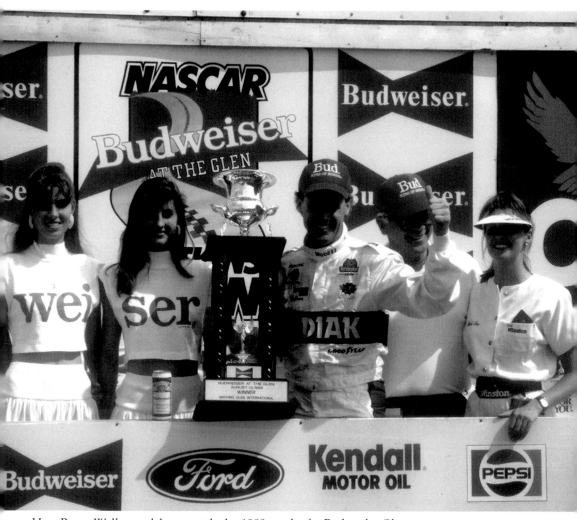

Here Rusty Wallace celebrates with the 1989 trophy for Bud at the Glen.

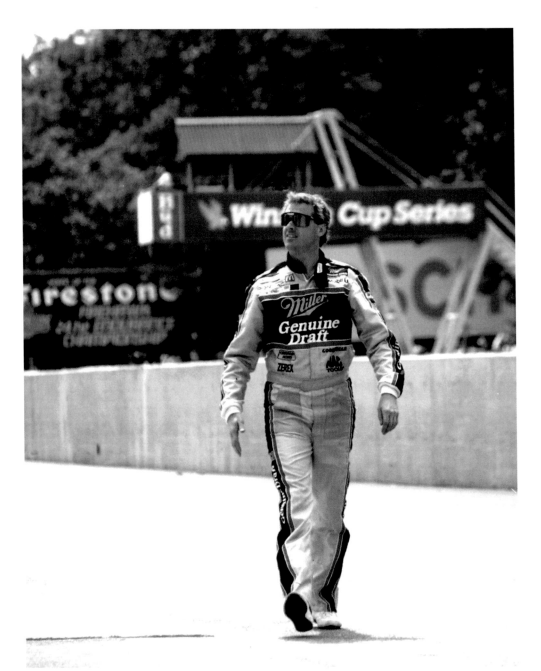

Rusty Wallace, shown here in 1990, also won the 1987 race. Other winners in Bud at the Glen included Ricky Rudd (who barely fended off Wallace in 1988), Mark Martin (in 1993, 1994, and 1995), Tim Richmond (the first winner, in 1986), Kyle Petty (in a 1992 race shortened by rain), Jeff Gordon, and local boy Geoff Bodine.

Gordon began racing at the age of five and finished third in Bud at the Glen in 1995. He won the race in 1997, 1998, 1999 (renamed Frontier at the Glen), and 2001 (renamed Global Crossing at the Glen). Gordon set a NASCAR Sprint Cup Series record of 124.580 miles per hour in qualifying heats at Watkins Glen in 2003. (Courtesy of Motorace Graphiks.)

DOWN THE ROADS AND AROUND THE TRACK

Tony Stewart also got an early start, winning the 1987 World Karting Championship when he was 16 years old. Stewart and Jeff Gordon collided at Watkins Glen in 2000, canceling each other out of competition and leading to some harsh words. But Stewart came back strong in succeeding years, winning Sirius Satellite Radio at the Glen in 2002, 2004, and 2005, and Centurion Boat at the Glen in 2007. (Courtesy of Motorace Graphiks.)

A CONCOURS D'INTEREST

The concours d'elegance is a gathering for show rather than competition. It was an indispensable component of any grand prix at Watkins Glen. Part of the fun has always been to see who shows up and what they come in. Manufacturers and designers take advantage of the automobile-savvy crowd to unveil new models. Owners of antique numbers polish up the brass and putt on down to join the crowd. High-finned 1950s models cruise the streets. Grizzled veterans of the earliest races brush shoulders unrecognized with dreaming boys and girls. One never knows who—or what—will be found at Watkins Glen.

The 1950 concours d'elegance featured a surprise entry. Notice the super compact car on the sidewalk across the street.

The fellow standing on the bumper in the right foreground is improving his view of vehicles leaving the show at the state park and turning north onto Franklin Street. The white building in this photograph has since been torn down.

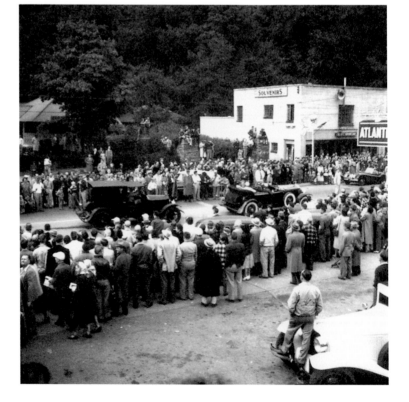

Here a little more of that old car is visible. Note the size contrast in the two vehicles at left on Franklin Street. There is even a high-wheeled bicycle seen behind the small car.

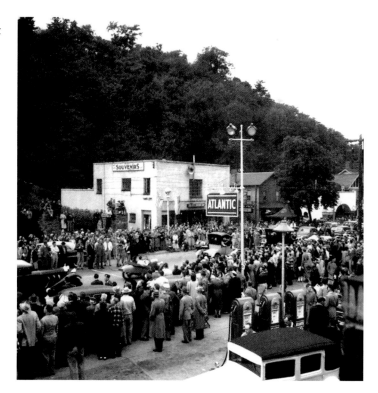

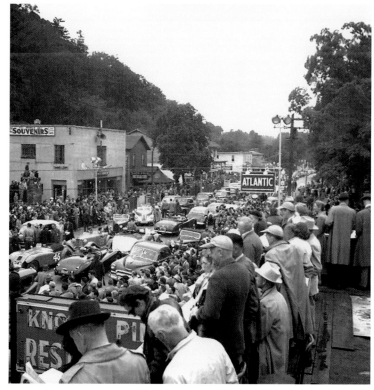

Folks crowd a restaurant roof to get a better view. Passing by are Phil Styles in the No. 46 HRG Aerodyne and Jack Wheeler in the No. 69 MG TD.

A CONCOURS D'INTEREST

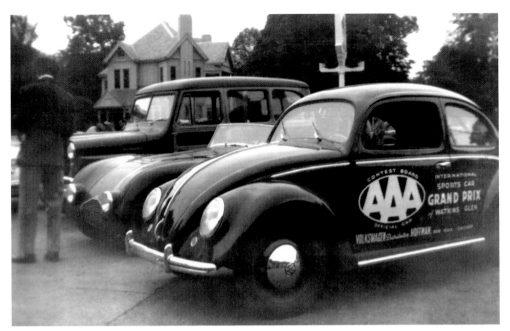

There were not just high-performance racers at Watkins Glen. A German automaker, new in the American market, donated the use of one of its vehicles as an official car.

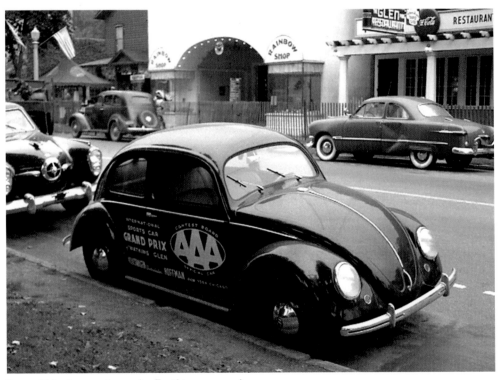

It would be interesting to know if it ever caught on.

DISCOVER THOUSANDS OF LOCAL HISTORY BOOKS FEATURING MILLIONS OF VINTAGE IMAGES

Arcadia Publishing, the leading local history publisher in the United States, is committed to making history accessible and meaningful through publishing books that celebrate and preserve the heritage of America's people and places.

Find more books like this at
www.arcadiapublishing.com

Search for your hometown history, your old stomping grounds, and even your favorite sports team.

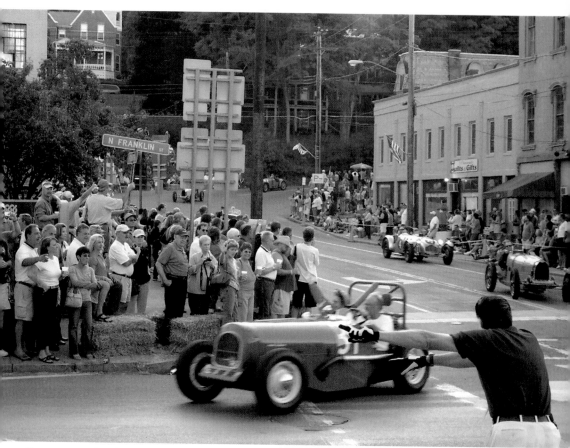

On some weekends, vintage cars parade on the original course. Spectators crowd the sidewalks behind the hay bales, recalling those days when the postwar world was fresh and young, when Americans were rediscovering the joy of the open road, and when the rumble of race cars echoed for the first time (but not the last) from the storefronts and the cliffs of Watkins Glen. (Courtesy of Schuyler County Chamber of Commerce.)

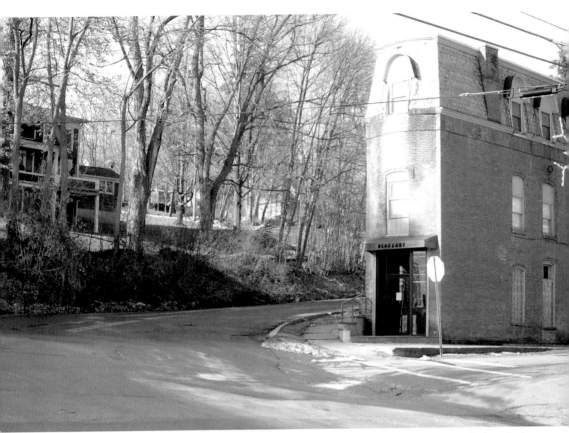

Finally reaching the bottom of that bend, the driver makes a hard left and a quick drop before a very short straightaway and a 90-degree right turn onto Franklin Street. After this corkscrew, it is a straight, level four-tenths of a mile to the start-finish line. Bill Milliken took the very first spill here in 1948, rolling up onto hay bales near where the photographer is shooting. He was only slightly hurt, and the turn is now immortalized as Milliken's Corner. (Photograph by Melissa Mitchell.)

WATKINS GLEN RACING

Friar's Corner, just past the upper entrance to the state park and just before the descending loop of the big bend, was named for Franciscan brothers who owned the land nearby and operated a seminary in the village. Racers reaching this point had covered five miles since the starting line. (Photograph by Melissa Mitchell.)

Big Bend is a long swing to the left and back again, but it also drops dramatically, as this image helps one understand. From this point, the driver descends to Franklin Street and lake level in well under a mile. Even at normal traveling speeds, it requires full attention. (Photograph by Melissa Mitchell.)

A CONCOURS D'INTEREST

This dirt road railroad crossing made enough of a bump to slow down drivers barreling through on the straight from Archie Smith's Corner. Even so, sometimes two or four wheels would leave the ground here. The New York Central Railroad agreed to stop the trains on racing days from 1948 to 1952. (Photograph by Melissa Mitchell.)

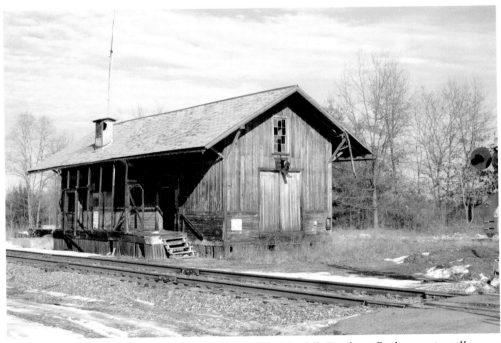

The road is paved now, but stop, look, and listen. The Norfolk Southern Railway train still comes through, and black bears turn up from time to time. The old depot forms a picturesque backdrop that would be instantly recognizable to the 1948 drivers. (Photograph by Melissa Mitchell.)

WATKINS GLEN RACING

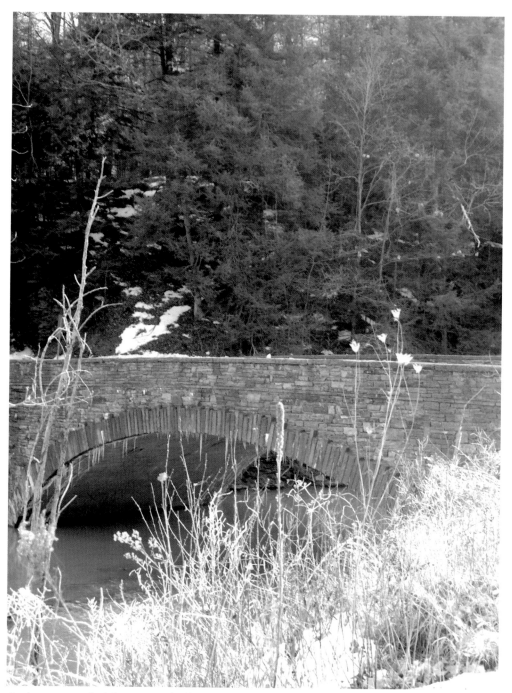

At the upper end of the state park, the Stone Bridge comes at the end of a long, narrow, twisting, sharp descent three miles from the start line. Denver Cornett flipped his MG here in the very first race, the 1948 junior prix. After throwing his helmet down in disgust, he got to work, borrowed a spare wheel from Briggs Cunningham, and drove the same MG in that afternoon's grand prix. (Photograph by Melissa Mitchell.)

A CONCOURS D'INTEREST

Twin pillars on each side of the street recall those days when cars and drivers champed at their bits here. (Photograph by Melissa Mitchell.)

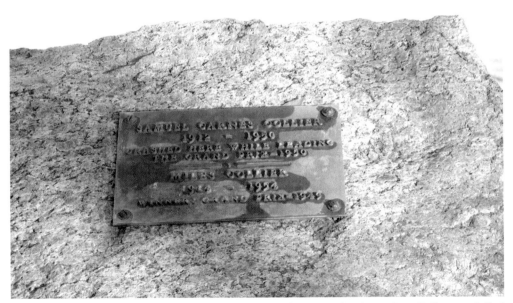

A marker set into a boulder commemorates the spot where popular driver Sam Collier was killed when his car flipped in the 1950 grand prix just beyond the railroad underpass. (Photograph by Melissa Mitchell.)

It is a lot of fun to retrace Cameron Argetsinger's original course (at a reasonable rate of speed, of course). The route is on the National Register of Historic Places. Brochures with information on the course are available at the racing center or at the chamber of commerce. The line across the street at left shows the original start-finish spot near the 19th-century Schuyler County Courthouse on Franklin Street. (Photograph by Melissa Mitchell.)

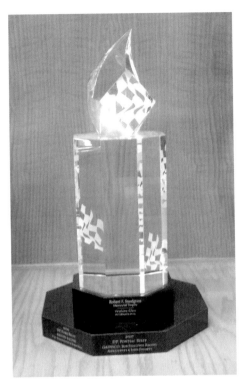

The formerly named Seneca Trophy was renamed the Robert F. Snodgrass Memorial Trophy in 2007 and is awarded to the winner of the Sahlen's Six Hours at the Glen. The base is granite and the trophy itself was handcrafted at Steuben Glass, a division of Corning Incorporated and a reminder of how Corning once intervened to keep Watkins Glen racing alive. (Photograph by C. R. Mitchell.)

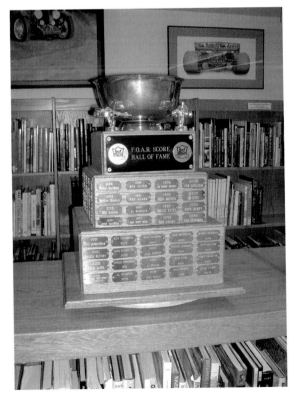

The F.O.A.R. S.C.O.R.E. (Friends of Auto Racing Seeking Cooperation of Racing Enthusiasts) Trophy encourages contributions to the sport. F.O.A.R. S.C.O.R.E., like Watkins Glen racing, began in 1948. The background gives some hint of the International Motor Racing Research Center's collections. (Photograph by C. R. Mitchell.)

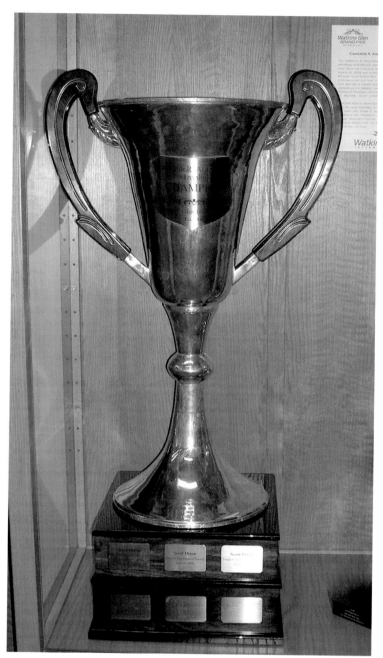

The International Motor Racing Research Center exhibits the Cameron R. Argetsinger Trophy, named in honor of the man who conceived the races. Three feet tall and nearly two feet across at the mouth, the sterling silver trophy is mounted on a cherry base. First offered in 2005 for the winner of the Watkins Glen grand prix, in each of its first three years it went to Scott Dixon. The design of this cup echoes the earlier Pedro Rodrigues Memorial Trophy (also at the research center), given to winners of the U.S. Grand Prix from 1971 to 1980. (Photograph by C. R. Mitchell.)

A CONCOURS D'INTEREST

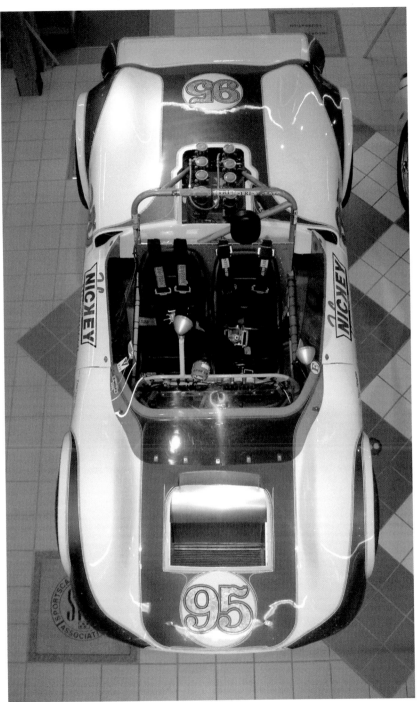

Dan Blocker, who played Eric "Hoss" Cartwright in the television show *Bonanza*, owned this 1965 Genie Mk. 10, which was sponsored as a racer by Nickey Chevrolet of Chicago. Drivers John Cannon and Bob Harris brought it in first at the Las Vegas United States Road Racing Championship and also raced in the 1966 Can-Am. (Photograph by Charles Mitchell.)

Original owner and driver Piet Nortier won the 1939 grand prix of Amsterdam in this BMW 328, receiving the laurel from Prince Bernhard. The car was hidden from the Nazis during World War II by burying it under hundreds of chairs the basement of an art museum in The Hague. (Photograph by C. R. Mitchell.)

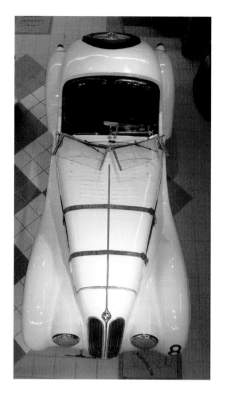

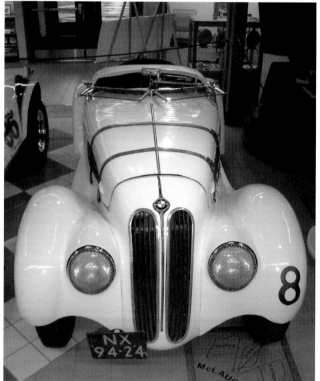

In 1997, 60 years after it was made, the BMW and its owner and driver, Fred R. Egloff, won the Vintage Sports Car Competition trophy. The vehicle is scheduled to return to the Netherlands soon. (Photograph by C. R. Mitchell.)

A CONCOURS D'INTEREST

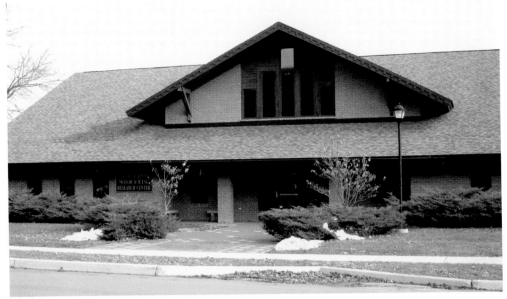

The International Motor Racing Research Center at Watkins Glen is a 5000-square-foot hub of archiving, collecting, research, and education. Though its mission extends beyond Watkins Glen, the town and its races lie very close to the heart of center personnel. (Photograph by Melissa Mitchell.)

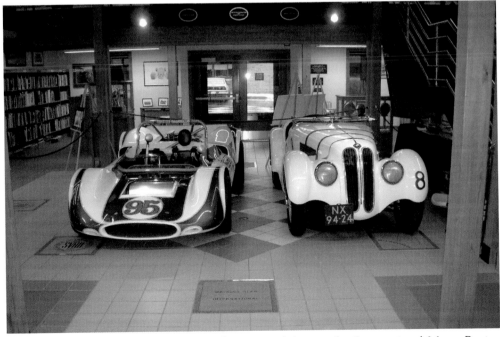

Interested visitors find films and some changing exhibits at the International Motor Racing Research Center, and there is nearly always a classic car in the lobby. As 2008 opened, contrasting racers from 1937 and 1965 shared the limelight. (Photograph by C. R. Mitchell.)

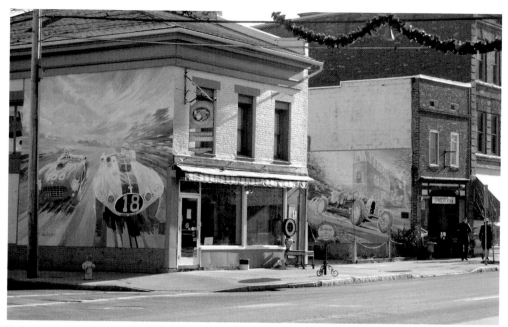

Bob Gillespie's outdoor racing murals remind residents, visitors, and racers alike of the village's history and enthusiasm. (Photograph by Melissa Mitchell.)

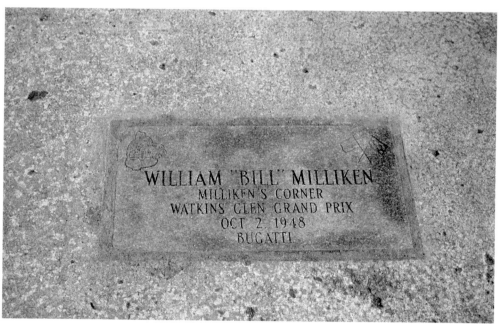

Anyone visiting the downtown of Watkins Glen should keep eyes peeled for Walk of Fame and other driver commemorative plaques set into the sidewalks. These honor great competitors from 60 years of racing at Watkins Glen. Bill Milliken drove in the first race and remains a proponent of the sport. (Photograph by Melissa Mitchell.)

A CONCOURS D'INTEREST

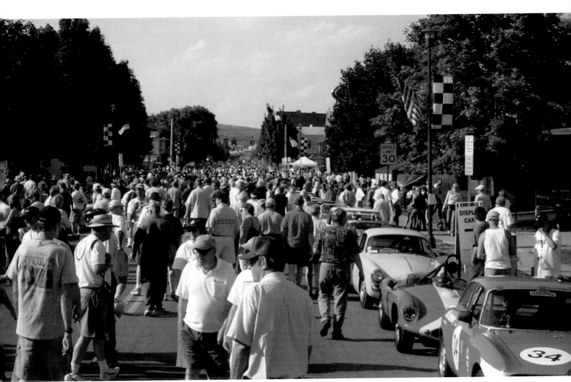

And the beat goes on. Even with the meets on a closed course outside the village limits, Watkins Glen overflows with visitors and crackles with excitement for race weekends and other events. (Courtesy of Schuyler County Chamber of Commerce.)

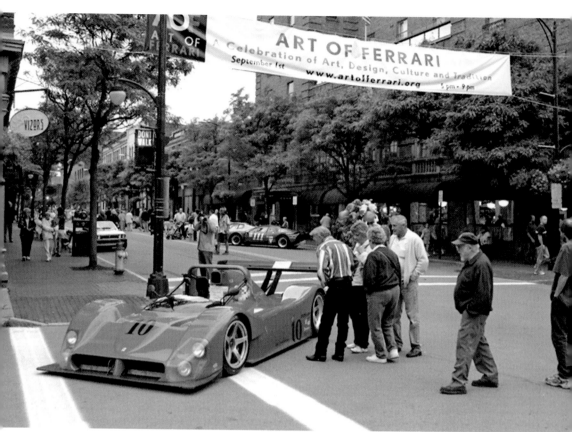

Neighboring communities such as Corning, Penn Yan, and Hammondsport also hold their automotive events. Hammondsport was a center of early motorcycle manufacturing, producing the Hercules, Curtiss, Erie, and Marvel brands. Art of Ferrari is a four-day event centered in Corning and stretching to Watkins Glen and beyond. (Courtesy of Leon Bourdage at the Art of Ferrari.)

One road rally featured this TR4A. (Photograph by C. R. Mitchell.)

There are also other tracks nearby, including the Black Rock Speedway and the Woodhull Raceway.

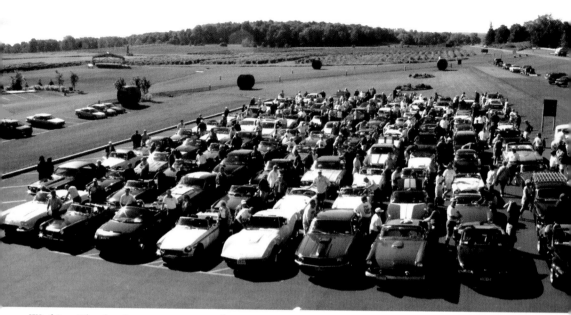

Watkins Glen has become a magnet for automotive enthusiasts of all stripes and at every level. Each year, a large road rally assembles at the track, cruises out to Glenora Winery on Seneca Lake, and then returns to Watkins Glen. (Photograph by C. R. Mitchell.)

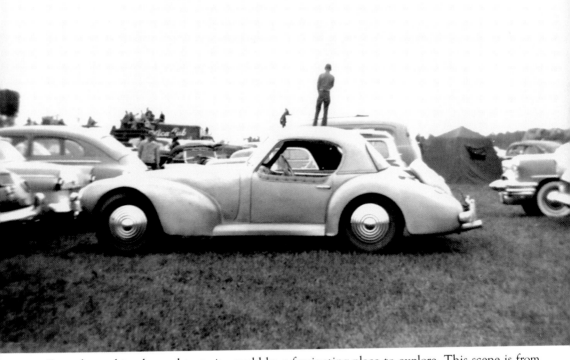

Even the parking lot and tent city could be a fascinating place to explore. This scene is from 1956, the first year for the closed course.

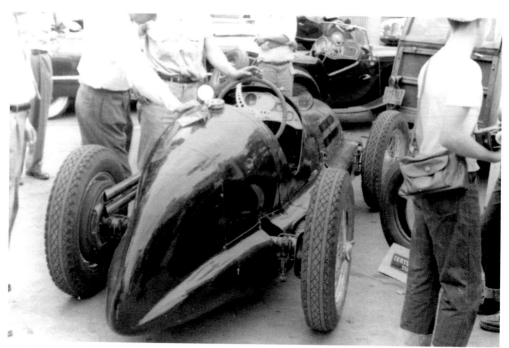

Brett Hannaway's Maserati has all he needs for racing and not a single ounce more.

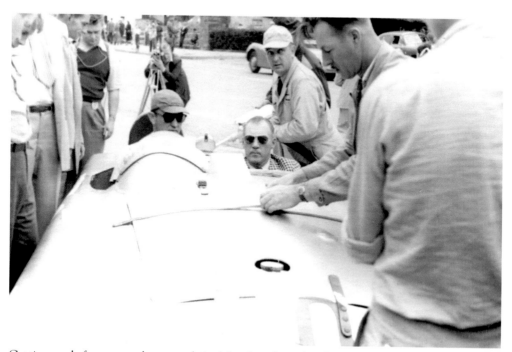

Getting ready for a race takes a good sized, hard working, hardheaded team. Notice that there is not a single smile among the highly focused crew.

A CONCOURS D'INTEREST

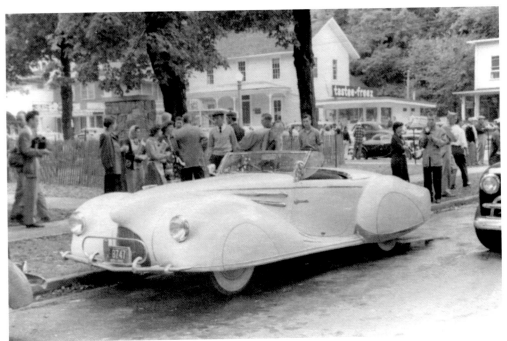

This vehicle, meanwhile, is getting attention from the young man with a camera at right. The nose suggests that the vehicle may be used for ramming should the occasion arise.

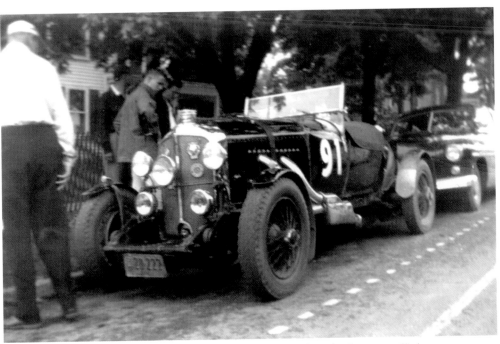

No. 91 appears to be a veteran of many hard-fought races, but the lacquer still gleams.

Notice how this machine's profile echoes that of the vehicle in the previous picture in futuristic styling. Notice also the ho-hum attitude of the Watkins Glen spectators, who presumably have seen everything by now, even this XK120 Jaguar.

On the other hand, a few people certainly paid attention to this convertible version of the XK120 Jaguar.

A CONCOURS D'INTEREST

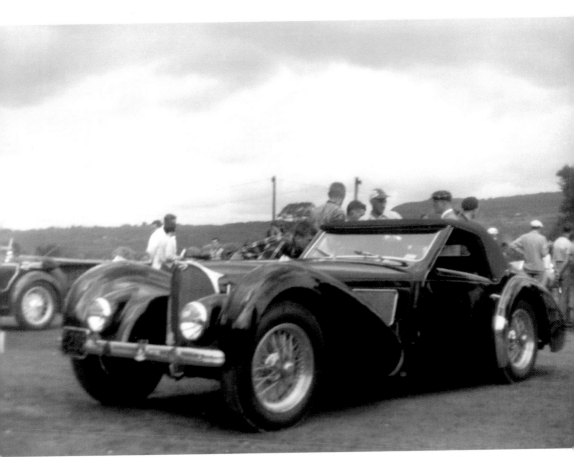

This vehicle would add a touch of class to any concours d'elegance in the world.

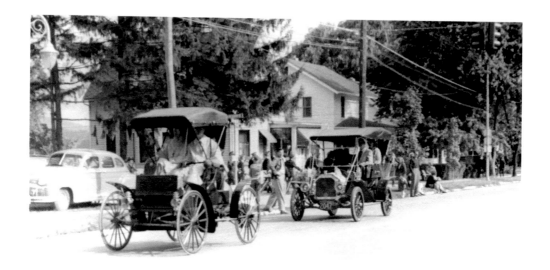

The Holsman in the lead has a rope drive, which no doubt needed to be replaced once or twice in its career. The Buick in the rear is a bit more traditional.

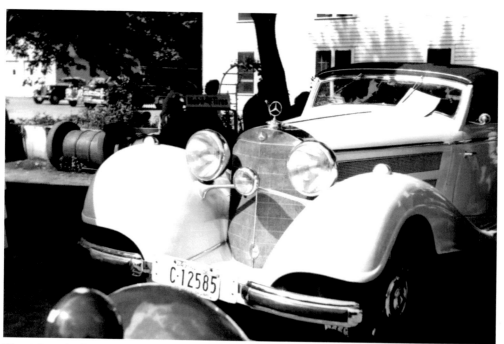

This Mercedes-Benz has Arizona license plates. Notice the rack of Mobil tires with its trademark logo in the background.

Briggs Cunningham tries out a slightly older model than he usually raced. He finished second at two 1948 races and also placed second in 1949 and 1950. He did, on the other hand, win the America's Cup regatta, as skipper of the *Columbia* in 1958. Cunningham also designed highly successful racing automobiles.

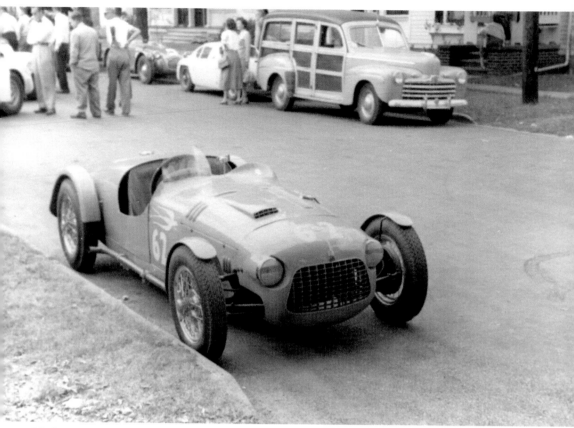

Modern spectators would be just as thrilled by the wooden-sided station wagon in the background as they would by Roger Barlow's Simca, a low-slung racer, in the foreground.

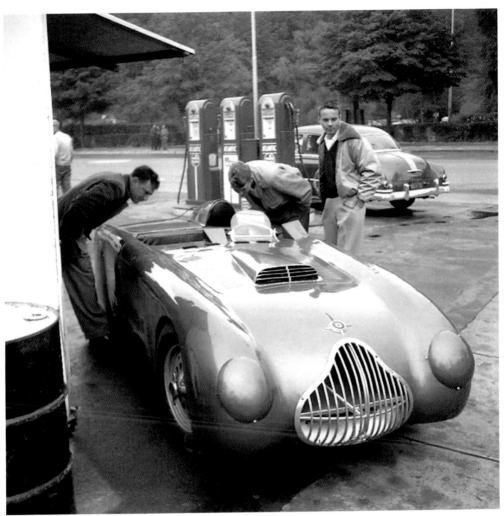

They may be dreaming of glory, and they may be inspecting very closely, but their hands are firmly in their pockets, and their postures are carefully curved to prevent smudging the finish on this Veritas.

I'M GOING!
U.S. GRAND PRIX
WATKINS GLEN, N.Y. OCT. 10

Races in the early days were hard fought, but a certain picnic air still prevailed. This sticker is from 1976.

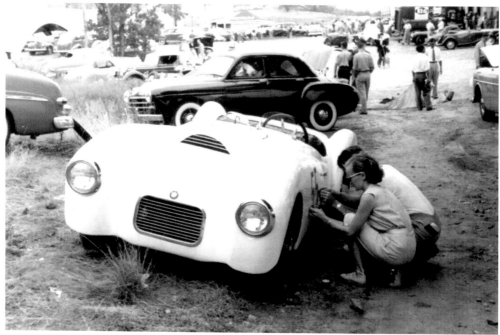

This couple is painting their competition number on at the Bridgehampton, New York, Road Races, featuring E. J. Tobin's BMW. This car raced at Watkins Glen in 1951 and 1952.

A CONCOURS D'INTEREST

This elegant Kinder 7 was on hand in 1952.

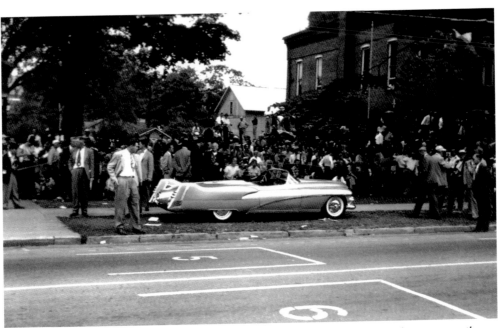

With all the automobile enthusiasts in town, Watkins Glen was a great place to unveil new products. Here, in 1951, a spectator looks over a LeSabre concept car from General Motors.

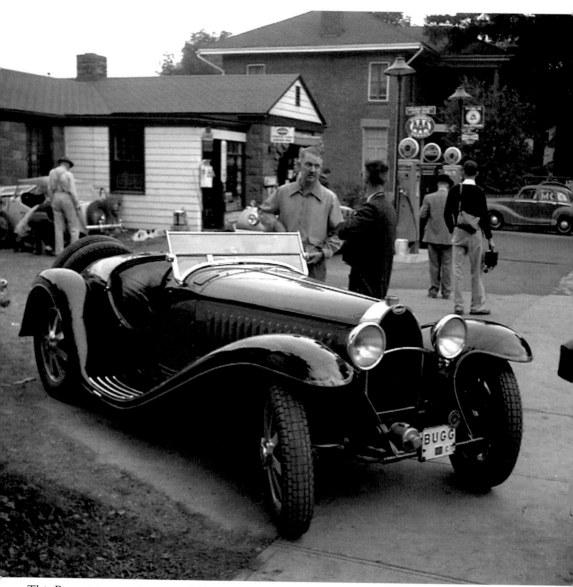

This Bugatti is attracting some fully justified attention at Smalley's Garage.